The Renaissance

Other titles in the series

The Renaissance

ROSA MARIA LETTS

CAMBRIDGE UNIVERSITY PRESS
Cambridge
London New York New Rochelle
Melbourne Sydney

Published by the Press Syndicate of the University of Cambridge
The Pitt Building, Trumpington Street, Cambridge CB2 1RP
32 East 57th Street, New York, NY 10022, USA
296 Beaconsfield Parade, Middle Park, Melbourne 3206, Australia

First published 1981

Printed in Great Britain by Balding & Mansell, London & Wisbech

British Library cataloguing in publication data
Letts, Rosa Maria
The Renaissance. – (Cambridge introduction to the history of art).
1. Art, Renaissance 2. Art, European
I. Title
709'.02'4 N6370 80–40357
ISBN 0 521 23394 1 hard covers
ISBN 0 521 29957 8 paperback

Acknowledgements

For permission to reproduce illustrations the author and publisher wish
to thank the institutions mentioned in the captions. The following are
also gratefully acknowledged:
cover, pp 1, 52, 53, 57 (left), 61 (below), 68 (right), 77, 80 (top right)
Fotografie della Societa Scala, Florence; pp 3 (left), 10, 11, 12, 13 (right),
16, 17, 18, 19, 22, 24, 26, 27, 28, 31, 38, 39, 40, 41, 44, 45 (below), 46, 48,
50 (right), 54, 56, 57 (right), 59, 61 (top), 62, 71, 85, 86 (top), 88, 89, 91
(right), 92, 93, 97 The Mansell Collection; pp 3 (right), 36, 45 (top), 69,
80 (top left) reproduced by courtesy of the Trustees, The National
Gallery, London; p 29 Editions d'Art Albert Skira, Geneva; pp 32, 68
(left), 73 Cliché des Musées Nationaux, Paris; p 33 (below) Institut
Royal du Patrimonie artistique; pp 35, 65 photographs Ampliaciones y
Reproducciones MAS; pp 50 (left), 81 Gemäldegalerie, Berlin; p 69
photograph Cooper-Bridgeman Library; p 74 reproduced by gracious
permission of Her Majesty the Queen; p 80 (below) Rosemary Davidson

Contents

The interpreter of reality

Tommaso di Giovanni
called Masaccio, *The Holy
Trinity with the Virgin, St
John and donors*, c. 1425–7,
fresco, 667 × 317 cm,
Santa Maria Novella,
Florence.

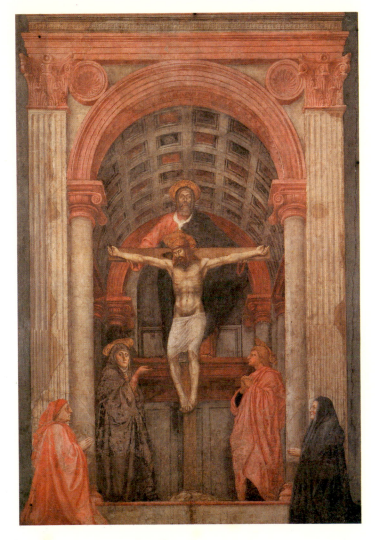

'He recognised that
Painting is but the
imitation of things as
they are',
Vasari on Masaccio in
*The Lives of the Painters,
Sculptors and Architects*.

The Florentines of the parish of Santa Maria Novella must have
gazed with astonishment at the unveiling of the fresco of the Trinity
painted by Masaccio about 1427 on the wall of their church. It
seemed as if someone had knocked a hole in the wall and built a niche
in it. Within the niche a divine event was taking place while two of
their own number, the donors, knelt in devout silence as if
astonished to find themselves in such a Presence.

1

In Vasari's *The Lives of the Painters, Sculptors and Architects*, written 130 years after Masaccio painted *The Trinity*, the bewilderment of the people of Florence confronted by such a new artistic 'language' still echoes. Whether this reflects the true reaction of Masaccio's contemporaries or simply the writer's own feelings, it is clear that Vasari was certain that it was the start of a new style. He introduced part two of *The Lives* as follows: 'Masaccio adopted a new manner for his heads, his draperies, buildings and nudes, his colours and foreshortenings. He thus brought into existence the modern style . . . the first of the painters to improve drawing . . . we shall see how greatly he was responsible for the rebirth of painting.'

The argument by art historians over whether the Renaissance (the word means rebirth) started a new artistic style, or gave final and more complete form to existing tendencies will never end. Nor is it all that relevant to the true appreciation of the individual works of art. Form in art is generally the outward expression of an idea. A certain consistency of forms and their treatment enables us to recognise a style. By looking at the outward expressions, whether paintings, sculptures or buildings, in the light of the ideas they contain, we may come to our own opinion as to whether novelty or continuity typifies the art of the Renaissance.

For instance, let us compare two panels both representing the Virgin and Child enthroned. The first is by Gentile da Fabriano, the great Italian exponent of the style now known as International Gothic, a style which had spread throughout Europe in the thirteenth and fourteenth centuries. The second is by Masaccio. Gentile's work was made about 1408, Masaccio's about 1426.

In the first, angels at the feet of the Virgin hold a musical scroll and sing. The Virgin sits in a leafy alcove; the Child holds a pomegranate. From the quick staccato 'rhythm' of the angels and greenery and the smaller creatures that are here symbolic of humanity, Gentile leads us into the solemn 'andante' of the divine figures. Mother and Child rise like a vision elegantly and flatly outlined against the gold ground that symbolises their spiritual dwelling. The figures taper in subtle harmony with the shape of the frame.

Gentile's representation appeals first and foremost to our sense of line, colour, pattern, to our pure sense of beauty. But, great as it is,

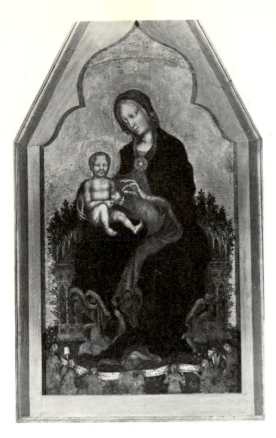

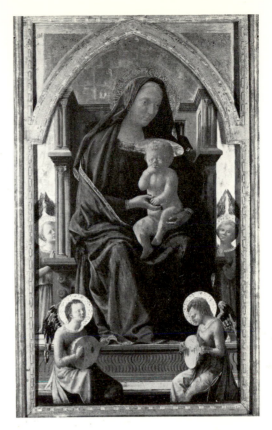

the picture does not even start to challenge our awareness of the
physical presence of the Mother and Child. The Virgin of Gentile is
an image from another world, an image for us to worship from afar in
faith.

Let us now look at Masaccio's Virgin enthroned, where an
altogether different musical event is taking place. Two angels sitting
at the feet of the throne are playing their lutes. The one on the right,
having just struck a chord, seems to be, as Vasari says, 'inclining his
ear very attentively to listen to the music he is making'. The angels'
size, even though on a smaller scale than that of the Virgin and
Child, is one with which we can personally associate. In this they are
unlike the minute angels of Gentile. And now we look up to the
plain, motherly features of Mary, comfortably holding the baby in
her lap. He is sucking a grape held in one hand while the other is
squashing the bunch in his mother's palm. The grapes, like the
pomegranate in the first picture, are symbolic of the coming suffer-

3

ing of Christ. The Virgin's sad gaze reveals her awareness of his inescapable future. But despite the mystical effect of this knowledge, Masaccio has described the pair in as realistic a manner as possible. The baby's uncertain attempt to find his mouth, the chubby legs and feet suspended in mid air, the warmth of feeling in the whole scene, bring the divine characters down to our human plane. We can identify with some of their feelings, with the distress of Mary, the serene cosiness of baby and angels.

Masaccio makes this possible by creating a feeling of real space all round the throne, starting with the first plane of the painting where a raised step seems to go right round to accommodate the little players. The careful use of the light shining from above on the receding planes of the steps, convinces us of the depth and dimensions. The scene is inviting.

In Masaccio's *Trinity* the invitation is even more open. The Virgin looks at us, pointing to the cross; the steps in the foreground are cut away; unfinished they suggest a continuation of space. From all this we deduce that a new attitude was growing up at that time between artist and public. The spectator is now invited to be part of the reality portrayed, to identify with the characters and the story enacted. Masaccio convinces the onlooker by masterly naturalism, by concentrating all elements of the picture into one overall theme, one demonstrable truth. The spectators, astonished and moved, like the donors at the feet of *The Trinity*, live the unfolding of a mystery: the mystery of the real world around them.

Naturalism is certainly developed in Masaccio's art as never before. But if we consider the imitation of nature to be the main characteristic of his art, we would merely imply that Masaccio continued to paint in the Gothic style. Interest in details and in the individual objects, in truth to nature and the painstaking rendering of it, all these things did not start with the Renaissance. Indeed, the naturalism of the early Renaissance can be seen simply as the continuation of a Gothic tendency.

The Gothic artist, for centuries already, had devoted himself to the careful rendering of things in faithful imitation of God's creation. This naturalism in painting and sculpture increased during the fourteenth century, becoming the distinguishing feature of the Late Gothic period, especially in northern Europe. There, the

people's natural tendency to careful observation thrived in the descriptive accuracy of their art.

But the naturalism of the Gothic artist did not aim at convincing the onlooker of the reality of the object or the event described. It did almost the opposite by placing things against artificial, even illogical, backgrounds, or with things which could never coexist in real life. A beautiful lady might sit in a garden stroking a unicorn, an animal which does not exist, or with wild animals happily snuggling at her feet. The symbolic value of many of these elements would go a long way to explain their presence in the picture, while their abundance and exoticism shows us the imaginative power of the Gothic world. It was a world where fantasy was at times the sublimation of a religious attitude, but more often a refuge from a grim reality. The medieval belief that man was too limited to understand or deserve the fruits of God's creation, was an added deterrent to facing the world as it really was.

The Renaissance artist, on the other hand, was the interpreter of a changed attitude of mind. To him man was not so much the humble observer of God's greatness as the proud expression of God himself, his natural heir on earth. Nature was not there to be gazed at and copied, but to be examined and understood; not to be feared, but to be mastered. The artist was still an observer of nature, but the work of art had become a study of nature in which the artist arranged all the parts logically into one organised comprehensible whole.

Tracing this change of attitude will lead us to the heart of the movement that we call the Renaissance. A change in thinking led to a change in artistic expression and that change is the new element in Renaissance art. Similarly, tracing those elements in Renaissance art which were continued from the Gothic tradition, will also lead us to the roots of the Renaissance by explaining its derivation.

Meanwhile let us note that around the beginning of the fifteenth century certain European artists began to show a new preoccupation with the world around them, wishing to interpret it as part of a teaching process to be shared with the public. These artists were by no means the majority, nor necessarily the leading ones. In Florence Brunelleschi, Donatello and Masaccio were at least second in the popular opinion to Ghiberti, Gentile da Fabriano and Lorenzo Monaco; in Flanders Hubert van Eyck did not enjoy the patronage

that the Limbourg brothers did. But they were the heralds of a new relation between man and reality. The emergence of their interest in things as they are, their struggle to express the new found truths, is the story of the Renaissance.

1 Origins of Renaissance art

THE REDISCOVERY OF CLASSICAL CULTURE

The period in European history known as the Renaissance, roughly the fifteenth and sixteenth centuries, was a time of great changes. It fixed the outlines of much of the world we know today. The kingdoms of Europe grew into strong states; there were changes in religion, in ideas and in behaviour. These, as we have said, were reflected in the work of great artists, especially in Italy. But the changes came slowly and drew upon many various sources.

The main change, which became the basis of Renaissance thought, was a new awareness of man himself as 'centre and measure of all things'. It came into existence in slow and continuous stages all through the fourteenth century through the rediscovery of the literature of the ancient world by the poets, philosophers and humanists.

Renaissance people studied especially the literature of Greece and Rome and found there an appreciation of nature and of physical valour. This led to a new esteem for man and nature which, as Christians, they regarded as God's creation.

Of course, these ancient, or classical, writings had never been entirely lost. For centuries the libraries of the monasteries had copied and stored books by Cicero, Virgil, Aristotle. But their collections were incomplete and often imperfectly understood. Gradually more manuscripts came to light and scholars outside the monasteries began to take a deeper interest.

PETRARCH AND HUMANISM

Francesco Petrarch was one such scholar. He was born in 1304 and studied law at Bologna. But he took little interest in the legal profession, preferring to spend his time reading and writing poetry both in Latin and in the Italian language. On his return to Avignon

7

where his family had lived since it was banished from Florence in the fourteenth century a suitable occupation was found for him as secretary to Cardinal Colonna, a Roman aristocrat attached to the papal court, then also at Avignon in the south of France.

Any man of importance in those times, king or pope, prince or cardinal, needed a secretary, that is a man of culture whose main occupation was to compose his patron's speeches, his letters and other important messages. These all had to be written in Latin. Sometimes the secretary became so famous, and was so much respected for his culture and literary style, that he delivered very important speeches to heads of state in person. Often he was sent as emissary from one court to another like a travelling ambassador. His credentials were his breadth of culture.

One can easily imagine the influence of such a man. Once he had won the confidence of his employers, he might be chosen as adviser in all sorts of matters. But the young Petrarch did not value his influential position very much; he preferred to spend his time continuing his studies in Greek and Latin literature, at his country retreat of Vaucluse, near Avignon. In this way the philosophy and the values of the ancients opened in front of him, and his medieval Christian upbringing was challenged by an alternative classical culture. The Greek love of physical beauty, of nature, of freedom and the ideals of the Greek city-states appeared side by side with the historical awareness, political power and firm determination of the Romans.

Out of that power Petrarch rediscovered the importance of liberal studies, or, as Cicero had called them, the *Studia Humanitates*: those studies considered essential to a free man in Greek and Roman times. These were grammar, rhetoric (the art of speech-making), history, poetry and moral philosophy, the studies which educate one to speak, read and write as a man of culture. *Humanist* was the name given to those who received such an education. Humanism is the name given by historians to the entire phenomenon in the fifteenth century. Rebirth or Renaissance, was the cultural movement that resulted, restoring to life a culture and values which had been buried for centuries.

The importance of humanism cannot be over estimated. Petrarch, who tried to widen the knowledge of the Greek language, very

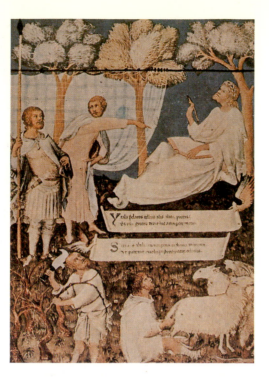

Simone Martini, title page
from a manuscript of
Vergil owned by Petrarch,
1340, 29.5 × 20 cm,
Ambrosiana Library,
Milan.

little known in Europe during the Middle Ages, could say that only
in that way might 'writers who had been dumb for years again come
to life'. He was referring of course to Homer and Plato.

Humanism spread, to begin with, mostly in Italy and France, but
by the sixteenth century it was known throughout Europe. During
the fourteenth century humanists were considered, by most of the
established intelligentsia, to be the cause of all evil! Cardinal G.
Dominici, a teacher at the university of Padua and writer of renown,
referring to Florentine humanists wrote that: 'They were the in-
strument used to corrupt politics, religion, family, education.' The
love of classical culture and the love of nature was their sin; even
Petrarch found it difficult to reconcile his love for beauty, plants and
flowers with his deeply held Christianity.

THE INFLUENCE OF THE ANCIENT WORLD ON THE VISUAL ARTS

Even before Petrarch, sculptors and painters were looking to the
ancient world for inspiration. In Italy, where the remains of Greek
and Roman art were everywhere to be seen, artists already had an
unconscious knowledge of classical sculptures and buildings. Thus,

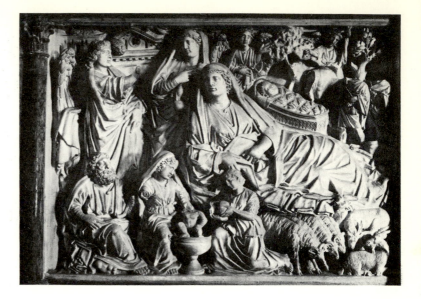

Nicola Pisano, *Nativity*, *c.* 1260, relief panel, marble, 85 × 113 cm, Pisa Baptistery.

around 1250, in the sculptures of Nicola Pisano, we find an awareness of classical statuary apparent not only in the thick enveloping forms of his draperies, but also in figures entirely borrowed from ancient groups.

Giotto, the greatest Italian pre-Renaissance painter, was the first to paint the Virgin Mary solidly placed on her throne, and looking more like a Roman matron than the mother of Jesus. Even though in the middle of the fourteenth century there was a rejection of Giotto's realism in favour of a more formal art, his and Pisano's message was not neglected for long.

This rejection and subsequent reaction were due to the Black Death, the plague which swept through Italy especially from 1348 to 1350 and made men, in anguish and fear, seek the Church's protection. They prayed to placate an angry God. Many artists did not survive. Those who did, artists like Orcagna, the leader of the Florentine School in the latter part of the fourteenth century, painted static images, isolated in cold celestial spheres. Images of death, glorified, triumphant and, alas, omnipotent, inspired most compositions. Orcagna's fresco cycle for the nave of Santa Croce in Florence, painted about 1350 with *The Triumph of Death*, *The Last Judgement* and *Hell*, reflects such an attitude both in content and style.

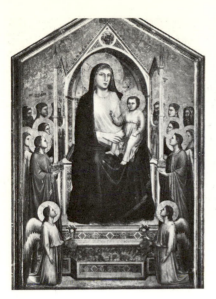

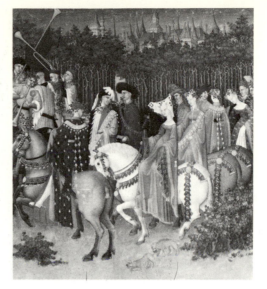

INTERNATIONAL GOTHIC – A NEW COURTLY STYLE

By the end of the fourteenth century a further reaction had come
from the French courts of Paris and Burgundy. A new zest for life
and a new love of beauty in objects, dress and entertainment is sud-
denly reflected in the miniatures and illustrations which, like a silent
film, unfold to tell us about the ornate and glittering court world.
This new style, called International Gothic, swept through Europe
in the opposite direction to that in which the Black Death had al-
ready passed. In this style the Limbourg brothers illustrated the
manuscripts of the Duke of Berry's prayer book, the *Très Riches
Heures.* In it are pictures of John, Duke of Berry, brother of Charles V
of France, spending graceful hours with his wife and ladies-in-
waiting, or with his hunting companions. There they are, on horses
as elegant as unicorns, riding through meadows not simply culti-
vated but combed, where the colours of the jewels, gowns and
weapons are of the same enamelled intensity as the sky, water and
foliage which surround them.

It is the world of an aristocracy, a privileged group of people who
appear for the first time in the history of Western painting to appre-
ciate and seek a life of comfort and of sophisticated taste. Nature is
taken into account, but it is a nature which has had to come to terms
with courtly life. To be included, it has had to be arranged, gilded,
set, all awkward corners smoothed away, in other words, tamed.

In Italy such a style enchanted artists like Lorenzo Monaco,

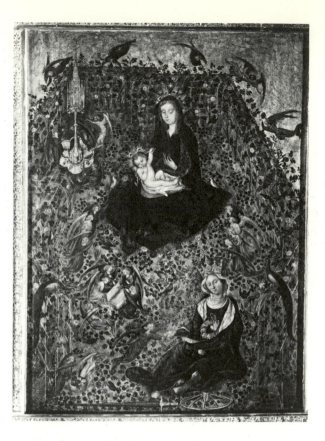

Stefano da Verona,
*Madonna of the Rose-
Garden*, *c.* 1420, tempera
on panel, 63.5 × 46.2 cm,
City Museum, Verona.

Gentile da Fabriano, Pisanello, Stefano da Verona, Gentile Bellini
and others. Furthermore these artists enriched the style with that
sometimes neglected, but in no way lost, component of medieval
Italian painting, the formal manner of Byzantine art. The rich
carpet-like effects of Stefano da Verona's *Madonna of the Rose-
Garden* evoke in its *hortus conclusus*, or walled garden, not only a
precious man-made and courtly nature, but also the subtle perfume
and enchanting mystery of the Orient.

As well as the interest in the exotic and sophisticated, the
International Gothic style certainly developed a new visual aware-
ness on the part of the public and a keen sense of observation in the
artist. It is obvious from the finished work that such exquisite
craftsmanship needed artists intensely aware of the shape and
quality of all objects, not least of natural ones. The sketch books of
numerous artists of this period reveal their skill. Pisanello's
drawings, for instance, are evidence of many hours of patient obser-
vation in the careful rendering of animals, flowers, the heavy, silky
folds of the train of a walking damsel, the feathers in the cape of a
gentleman's costume.

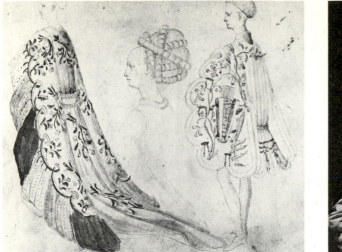 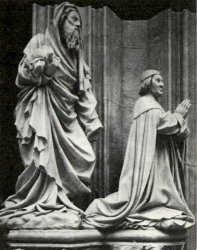

In these pictures, which still appear largely as exotic linear patterns, the earlier Gothic composition which had no centre or logic is abandoned in favour of images that focus around man and his environment. Whether it is the court nobles riding in the Easter sunshine, or the farmer warming his limbs by a cosy log fire, man's activities and moments of rest are depicted amidst a most enchanting, if a somewhat stereotyped world.

The ultimate reaction to the Black Death was a rebirth of belief in man, in nature and in a benevolent God. In Burgundy around 1400, in that same court where the Limbourg brothers were creating their Gothic masterpieces, a more robust and weightier manner was to be found in the works of Claus Sluter. In a series of sculptures for the Chartreuse de Champmol, near Dijon, which was to receive the tombs of the dukes of Burgundy, a new treatment, sober and serenely classical, can be seen taking shape side by side with the Gothic style. In Sluter's marble group of Duke Philip the patron saint has a typically Gothic broken profile of agitated draperies. In contrast the unbroken silhouette of the kneeling duke, contained in a well defined triangle, introduces a new manner. The lack of any details to detract from the main theme and the stark simplicity of the treatment of the marble surface, remind us of Giotto and Pisano rather than of the contemporary Gothic style.

2 The early Renaissance in Florence, 1400–50

'The Renaissance happened in Florence when one returned to the forms of the noble and ancient statues and the rules of nature.' Ghiberti, *Commentaries*

THE COMPETITION FOR THE BAPTISTERY DOORS

In the fifteenth century, England, France and Spain were growing into strong kingdoms, but Italy continued to be a country of small city-states vying with each other in commerce, war and the arts. Florence was no exception though around 1400 it was enjoying a period of relative calm. Citizens from the seven major guilds took turns at holding public office in the commune, or town government, and ran the city's affairs under the protection of powerful merchant families. The commune maintained the republican liberties so much treasured by the Florentines. At a time when authoritarian aristocratic rulers dominated most Italian communes, criticism, dissent and the discussion of political, social and artistic problems remained one of the activities most enjoyed by the citizens of Florence. Indeed this dissent seems to have given inspiration to the men in authority. Then in 1400, an attempt by the Duke of Milan, Giangaleazzo Visconti, to conquer Florence by bringing up his troops outside the town walls temporarily united the citizens against a common foe. But the sudden death of the duke removed the threat. The Florentines took that event as a sign of God's justice. It marked their special place in the history of Italy as defenders of civil rights and regional liberties.

In this climate of optimism and municipal pride, the guilds renewed their efforts to enrich the town with buildings befitting its new role of defender of the *Res Publica*, or as the Athens of the Italian peninsula. The guild of the wool and cloth merchants, the Calimala, heralded in the new century with a competition to build a pair of bronze doors for the Baptistery of St John, an octagonal building in the heart of Florence.

An original pair, cast by Andrea Pisano in 1336, and showing scenes from the New Testament and the life of Mary in four-lobed frames, determined the limits of the competition. Within a year, a

14

story from the Old Testament of the Sacrifice of Isaac, cast in bronze and set in a similar frame, was to be submitted to a commission appointed by the guild. Seven competitors were listed by Vasari (six in Ghiberti's commentaries). Ghiberti himself and Brunelleschi, Jacopo della Quercia and Donatello were among them. Answering the challenge were artists from both traditions: the Gothic 'from the other side of the Alps', as Vasari called the French style, and the more local style of Roman derivation which had influenced Italian art since Giotto and the Pisanos.

The story of the sacrifice must have been laid down in detail by the commission since two competition panels, still in existence in the Bargello Museum in Florence, contain precisely the same elements. Abraham, on top of a hill, is about to sacrifice his son Isaac to God. He is suddenly stopped by an angel arriving from above, who points out a ram to be sacrificed in Isaac's stead. Two servants are waiting below by a stream where an ass is drinking. So full a programme for such small panels gave the artists the problem of combining clear narrative and skilful composition. They had to convey not only the details of the place but also a precise moment in the story.

Soon the field was reduced to two contestants, Lorenzo Ghiberti and Filippo Brunelleschi. Ghiberti was well versed in the Gothic tradition passed on to him by his father, Bartoluccio, a goldsmith extremely skilled in the technique of casting. He was already considered one of the best sculptors of Florence. Vasari mentions that he had benefited in his youth from the teaching of a French sculptor though nothing more is known about that. He was also a lover and connoisseur of antique bronzes and sculptures of which he owned quite a number.

Brunelleschi, as a young man, was destined by his father to become a notary. However, he was eventually allowed to follow his real interest, the arts and design, then taken to mean the invention of all sorts of techniques and machines. He started in a goldsmith's workshop, and was soon embossing and engraving on silver, casting small figures in metal, carving, making clocks, planning buildings.

The panels submitted by the two artists, similar at first glance, were in fact quite different. They became the source of heated discussions not only among the judges but among the citizens of

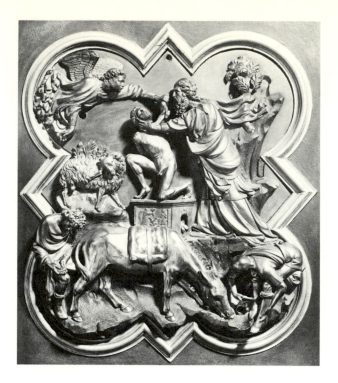

Filippo Brunelleschi,
Sacrifice of Isaac, 1401–2,
bronze, 53 × 43 cm,
Bargello, Florence.

Florence. In each panel the emphasis and treatment of the various elements give a very different rhythm to the narrative. If we ask which panel is more naturalistic, which is more descriptive, which is the better work, we must answer, almost without doubt, Ghiberti's. So magnificently harmonious is the balance of the two parts into which he divides the composition; so 'melodious' is the treatment of Abraham's body with its elegant curve brought out by the receding landscape. Bathed in an unimpeded light, Abraham appears in full relief, almost like a free-standing statuette. The body of Isaac is modelled after a classic Apollo; the back of the first servant is softly shaped under the draped cloak; the flow of Isaac's tunic is suggestive of the flow of the water beneath. Furthermore Ghiberti executes the whole most skilfully in only one cast. Brunelleschi's was cast in seven parts and welded together.

But where are the problems of space and time, of the setting and of the event solved with greater urgency? In Brunelleschi's. Even though he tends to represent the natural elements almost with symbols – cliff, tree and water are expressed in a sort of shorthand – nonetheless they are rendered with tremendous force. Kept in a low key, the whole background creates a space in which the unfolding of the story acquires special resonance. Isaac's body, in broken zig-zag

16

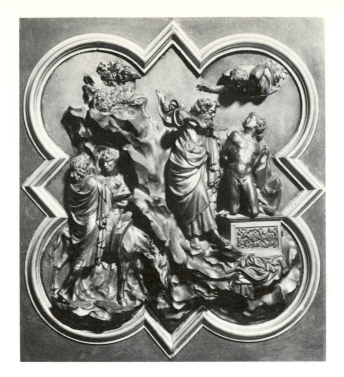

Lorenzo Ghiberti,
Sacrifice of Isaac, 1401–2,
bronze, 53 × 43 cm,
Bargello, Florence.

lines, recoils under the desperate but determined hold of his father.
Abraham is halted, by the sudden grasp of the angel, from inserting
the knife in the throat of his own son. No means are spared to convey
the physical violence inherent in the biblical episode. Things are
happening suddenly. Even the ass, reaching to find some water in
the shallow river bed, shows stretched muscles and bones sticking
out of his body as he struggles to balance on the uncertain terrain. It
is more brutal, less elegant, but more convincingly true because of
the seeming inevitability of the action. In Brunelleschi's panel the
time and the place of the events acquire for the first time an emphasis
that is more historical than supernatural.

Ghiberti's composition, perfect as it is, is made up of two distinct
parts, each to be apprehended separately; Brunelleschi holds the
story within a pyramid starting from Abraham's head and raised
arm, and continuing on the right along the back of the old man and
down to the crouching servant. On the left the shadow thrown by the
angel's curving body continues down to the ram and the servant.

Both artists looked to antiquity for inspiration: Isaac's body in
Ghiberti's relief has already been mentioned; in both panels the
urns under the kneeling youths are derived from classical proto-
types; the left-hand servant in Brunelleschi's relief imitates the

17

Spinario a well-known Roman bronze of a boy removing a thorn from his foot. But while Ghiberti looked to antiquity, as one would to a collection of jewels or curios from which to borrow an idea or a stone to fix in a different setting, Brunelleschi, as we shall see, looked at the art of the ancient world methodically. He looked at it as at a complicated and fascinating piece of machinery, in order to understand its workings. He was still trying to work out the guiding principles of his style. He was looking around, open to more than one suggestion. This explains his awkward passages, his almost unrefined finish, his overcrowded arrangement. Ghiberti is at the end of a mature tradition, his language is polished; he can even allow himself an up-to-date touch in keeping with the new humanistic culture. He was of course the winner of the competition.

BRUNELLESCHI AND DONATELLO IN ROME

Brunelleschi soon felt the need to continue his lessons from antiquity and departed for Rome with Donatello, his young sculptor friend. There he spent quite a few years, and Donatello a shorter time, looking at, drawing and copying ancient buildings and statues, even digging out the statues, and uncovering buildings and other remains. One can imagine these two young men, like two students discussing their experiences and future plans, in the light of a past so great as to fire their dreams and hopes of glory both for Florence and for themselves. Brunelleschi joined to his practical and artistic knowledge a great literary culture. He knew the Bible by heart and also the Italian poet, Dante; in mathematics and geometry he could confound his own teachers. Theory and practice, linked together, strengthened the inventiveness of this first example of an ideal Renaissance artist: sculptor, architect, painter, scholar.

Finally around 1410 Brunelleschi returned to Florence well equipped to bring to completion the greatest project of the Florentines: the dome of Santa Maria del Fiore, the town's cathedral.

Boy pulling out a thorn, bronze, Capitoline Museum, Rome.

Unknown artist, *View of Florence*, 1342, detail from fresco, *Madonna della Misericordia*, in the Loggia del Bigallo.

A NEW ARCHITECTURE FOR A RENAISSANCE SOCIETY

Looking at a fresco showing a view of Florence in 1342 it seems hardly possible that the Florentines had been worrying since at least 1299 about town planning, and widening and straightening their streets for reasons of beauty and comfort. But we know that the poet Dante was a member of a commission set up in that year to widen and straighten city streets; and that ten years earlier the commune granted permission for property to be bought in front of the church of Santa Maria Novella in order to enlarge its piazza. Then in 1327 a petition had been presented to the commune describing the area in front of the Carmine church as a 'filthy place, a dumping ground for trash' which put to shame the whole neighbourhood. It asked the authorities to buy the land in question and turn it into a piazza 'so that what is now unsightly and vile will be made attractive for the passerby'. But if we look at this fresco, a very different picture from the one we might have formed from reading the documents, appears before us. The buildings are crowded together. Each many-storeyed house reaches a little higher, robbing its neighbours of light and air.

All through the fourteenth century petitions from associations and citizens, commissions set up to improve conditions in the city and laws passed to force people to pull down high buildings seem to

19

have brought very few results. This was partly due to the flexibility of the authorities in applying the laws, and partly to the able manoeuvring of the owners to avoid the regulations. By the end of the fourteenth century the fines paid by the owners for not complying with such regulations had become a regular source of income for the commune!

Nevertheless the desire for wider space, for harmonious and beautiful buildings set in adequate surroundings, was a widespread ambition of the people of Tuscany. In 1309 Siena, in an eloquently worded proclamation, maintained that 'those who are charged with the government of the city should pay particular attention to its beautification. An important and essential ingredient of a *civilised community* being a park or a meadow for the pleasure of both citizens and foreigners.'

A HUGE UMBRELLA OVER THE HEART OF FLORENCE

The Florentine community of the fourteenth century had been able to prepare at least the setting for the building that, once finished, was to be such a testimony to the civilisation of those times: the cathedral and dome of Santa Maria del Fiore. Started by Arnolfo di Cambio in 1296, the building had continued under the direction of Giotto with special emphasis on the bell tower. The work continued with exasperating slowness during the latter part of the fourteenth century though the commune did demolish buildings so as to offer deep-set vistas of the cathedral. They widened surrounding roads to 21 metres 'so that this cathedral will be encircled by beautiful and spacious streets and buildings resounding to the honour and utility of the Florentine citizenry'.

Florence's cathedral had been planned with a long nave and two aisles all ending in an octagonal space, or tribune. Chapels radiated from each side of the octagon like the petals of a flower, almost as if to illustrate the church's name. The width of the nave and aisles meant that an extremely large space had to be covered, yet covering it with a dome would have been impossible with the contemporary technical knowledge. At that time vaults were built like arches by the centring method: a beam was placed across the archway on top of

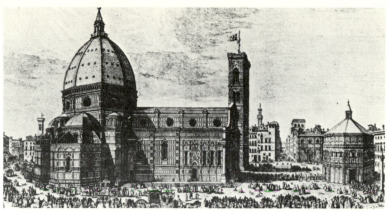

Florence cathedral.

the walls. A wooden framework on the beam supported the bricks of the arch until the desired height was reached and the final round of bricks became self-supporting by the insertion of a final centre brick, the keystone. This held the arch in place by pressing the bricks one against the other. The supporting woodwork could then be removed. To build a vault across the nave and aisles of Santa Maria del Fiore would have needed a beam wide enough to reach across from one side of the octagonal tribune to the other, a span of about 43 metres. Such a beam simply did not exist.

Brunelleschi, however, examined the Pantheon in Rome and other Roman vaults and found a way to build a dome by resting on the octagonal stone drum a series of concentric rings, or horizontal courses of brick and stone, each strong enough to support the next. The stones then formed eight heavy ribs resting on the corners of the octagon.

For insulation, as well as magnificence, Brunelleschi built two domes, an external and an internal one. This went further to reduce the weight of the outer dome. Now it stands out, ample and magnificent, on Florence's horizon. Between the ribs, the elastic tension of the intervening panels seems to hold the dome open as if filled with air like a huge umbrella opened over the heart of Florence.

The vast dome with its curved silhouette does not relate only to the quarters and streets of the town which seem to radiate from it, but also to the hills of Tuscany which surround the town. The dome of Santa Maria del Fiore was to crown Florence, not only as a medieval city-state, but also in its new role as capital of Tuscany. For this is what Florence became in the third decade of the fifteenth century when it had conquered most of its neighbouring towns: Pistoia, Arezzo, Pisa and Siena. The artist Alberti, who understood the wider political meaning of Brunelleschi's building, said that the

21

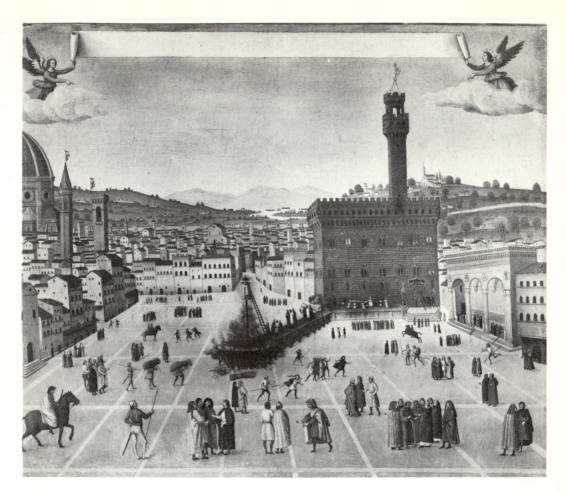

Unknown artist, *Burning of Savonarola in the Palazzo Vecchio*, 16th century, Museo di San Marco, Florence.

dome was 'large enough to contain all the people of Tuscany'. Looking at their completed cathedral, with all its parts in play from Giotto's bell tower to Brunelleschi's dome, with the magnificent outer walls of the nave emphasised by the geometric effects of the white and green marble, with its spacious surroundings, the Florentines must confidently have felt themselves to be a civilised community.

As it finally stands today in the space created for its enhancement, displayed like a precious gem in a setting of carefully calculated distances, Santa Maria del Fiore offers itself freely to the blue skies and radiant sun of Florence, a fusion of perfect nature with perfect art. Around it the streets leading towards the Baptistery provided space for religious and civic groups to parade in the centre of the town.

At a stone's throw from the cathedral the greatest setting of all

was being built during those same years, the Piazza della Signoria. The Palazzo Vecchio, the town hall, had been completed in 1314. The square in front of it, obtained by pulling down the property of families in political disgrace (like Dante's, Petrarch's or Alberti's) was paved in 1330, and the loggia built between 1376 and 1382. There important speeches were delivered; great political and ecclesiastical figures, ambassadors from all over the world, were received and entertained with the show of the day, be it pageantry, procession, state occasion or simply the parading of the elegant and fashionable of the city. Later in the century, carnivals and tournaments were organised there under Medici patronage and weddings and private or public ceremonies were carried out under the careful direction of the commune, the patricians and the artists of Florence.

These settings, streets and open spaces, the result of a long period of planning, had their effect on the young artists of the fifteenth century who tried to reflect them in their panels and frescoes. The frescoes of the fifteenth century could not be like those of the previous century because, to say the least, the subject matter had changed.

FROM STOA TO PORTICO

Before long quite a few more public squares were completed outside the main churches of Florence. Most of them were surrounded by porticoes with columns or arches. Brunelleschi's Foundling Hospital, the Spedale degli Innocenti, his first civic building in Florence, shows once again the artist's concern to relate the building to its immediate surroundings and to the needs of the community.

The Spedale, the first public hospital for the care of abandoned babies, was donated to Florence by Cosimo de Medici, the powerful wool merchant, banker and leader of Florentine politics. With the project there started one of those special relations between artist and patron which have often influenced whole periods in art. As a result of this relationship Florentine architecture from the 1420s to the 1440s answered the needs both of the mercantile society so perfectly embodied in Cosimo, and of the renewed historical and civic consciousness so developed in Brunelleschi.

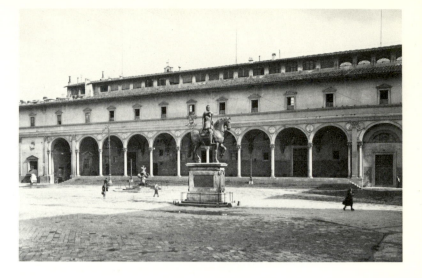

Filippo Brunelleschi,
Innocenti hospital,
Florence, 1421–6.

Brunelleschi was conscious of space not only as a void to be filled but also as an area with a specific civic function. The elegant façade of the hospital, dominated by the slender arcaded portico, is planned in relation to the square as well as to the building. For instance, the proportions of the façade take both the building and the square into account. If we think of the portico as a frame for the square we can see how alternating light and shadow emphasise the white columns and arches. If we think of the portico in relation to the building then we see how the cool shaded bays invite the visitor to enter. The stepped-back effect of the top floor with its long row of windows gives the impression of the building finally withdrawing into the privacy of its own interior.

When he provided the portico, a covered but open area for the citizens to meet and for staff and visitors to halt on their way in or out, Brunelleschi must have had at the back of his mind not only the Italian climate but also social and historical considerations. From this moment the portico acquires added importance. It is heir to the Greek *stoa* (colonnade), or covered area where people assembled, like the Stoa Poikile in Athens where Socrates used to teach. Equally it continues the ancient Roman colonnades, especially those built around a forum for the citizens to meet in private or public gatherings. It is both the ornament and pride of a Renaissance building, and the frame and extension of its adjacent square.

THE TOWN HOUSE OF THE FLORENTINE MERCHANT

Some of the leading Florentine families who had stubbornly avoided pulling down their crowded quarters under the commune's regulations were now building new spacious houses called, in Italian, *palazzi*. They were buying the surrounding buildings in order to demolish them and make ideal settings, or small squares, leading to vistas for their new façades. The Medici, Pitti and Rucellai families commissioned architects like Brunelleschi, Michelozzo, and Rossellino to build or renew their palaces.

The Medici palace was the first large-scale private dwelling produced in the fifteenth century. Commissioned from Brunelleschi by Cosimo de Medici around 1434, it was eventually built by Michelozzo in 1444. Tradition has it that Brunelleschi, who had become a personal friend of Cosimo, was so delighted by the commission that he produced the plan for a palace so luxurious and magnificent as to arouse fears in Cosimo's prudent mercantile mind. Cosimo, the quiet manipulator of Florentine policy, for peaceful and good ends as well as Medici interests, did not want to provoke the envy of the other powerful families. Most of them already hated him enough for having taken their place in Florentine politics.

The palace eventually built by Brunelleschi's pupil Michelozzo, with its original five-bay façade, was a beautiful and imposing town house. What stands now in Florence, the Medici-Riccardi palace, is a building much extended by Riccardi's additions. However, if we compare it with the last palace built during the previous century, the Davanzati, we notice at once the expression of a different way of living. Since in most cases the palaces were inhabited by well-to-do merchants who lived on top of their business premises, the buildings had to be warehouse, office and house in one. The Davanzati's palace façade is divided into four storeys, with the lowest one, obviously the warehouse, presenting a well-fortified look, with large sturdy doors and small windows set high. Such houses, and the public buildings erected in the same century, even contained a well within their strong walls, so that the family would be self-sufficient and protected for a few days in case of rioting. But even the floors above, reserved for the use of the family, show a rather grim unfriendly look. Although the flow of arches framing the windows is

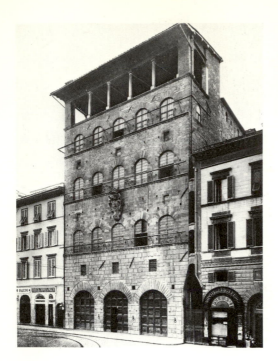

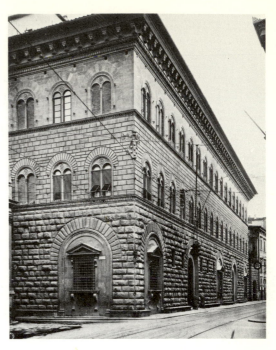

beautifully harmonious, the façade does not open outwards with the progressive interpenetration of spaces typical of Brunelleschi's buildings. Fortified and self-sufficient it does not dare to smile at the passer-by.

The Medici palace speaks a different language. The rich merchant's house and office now welcomes the visitor. The five arches of the lower floor, only later modified at the corners by Michelangelo into bricked archways with windows, were all open, allowing a glimpse of the internal symmetry of the courtyard. From the central arch which looked straight into the centre of the courtyard one saw, not a well, but a statue of Judith by Donatello. Outside and all around the house the base of the massive lower storey now advances towards the road, forming a welcoming seat. And we can indeed imagine Cosimo and other men of his household, in that first period of the Renaissance, still relatively frugal, homely and simple, sitting out to enjoy the afternoon sun, sharing the seat with other citizens and passers-by, perhaps with an old man who in his youth had worked in the Florentine cloth shops.

The same feature of a sun seat, now raised in status by an elegant diamond-pattern back, is visible in another Florentine palace, the Rucellai, begun in 1446 by Leonbattista Alberti. Alberti, whose family had been exiled from Florence in the fourteenth century, was

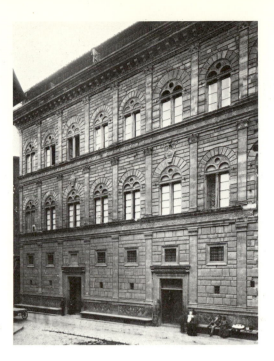

Leonbattista Alberti,
Rucellai Palace, Florence,
1446.

a papal secretary in Rome. A humanist but also painter, sculptor and architect, his ability to translate his artistic work into written texts, made him a key man for explaining Renaissance artistic theory.

In Alberti's Rucellai palace classical forms were for the first time applied to a palace façade. The traditional partition into the horizontal bands corresponding to the various floors, and underlined by cornices stressing the sturdiness of the façade, is here broken by a vertical system of pilasters with the classical orders, doric first and two types of corinthian to follow. The façade was probably inspired by the Roman Colosseum. Besides giving the building a vertical thrust, these pilasters create a magnificent grid which seems to hold the façade in a tight grip. The base of the pilasters, besides achieving greater height for the ground floor, becomes the back of yet another noble sun seat.

Alberti's façade, however, remained an isolated example. Other palaces returned to the more traditional type marked by the horizontal bands which allowed greater scope for future expansion. The Pitti palace, for instance, built for Luca Pitti in 1458, perhaps after a design by Brunelleschi, was originally planned with only seven bays. It was eventually extended to its present eleven bays, when, in the sixteenth century, it became the residence of the Medici, the Grand Dukes of Tuscany.

27

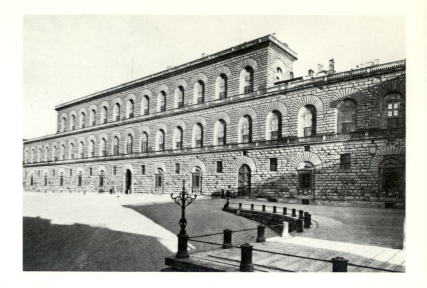

Pitti Palace, Florence, 1458.

For the first time since the classical era of Greece and Rome, space and buildings were planned and measured to fit man's requirements. They were conceived for the *homo liber*, the free man of the city-state as he went about his business, religious or social activities, proud of his private as well as his civic display.

The art and architecture of these first fifty years of the fifteenth century in Florence reflected the ideas and aims of the society. No more do superhuman cathedrals and spires reach higher and higher towards the sky; no more are there the heroic and crenellated knightly castles. Instead there is the plain geometric space of a town square, with porches open to the sun and to the bystanders' gaze. There are thoroughfares for processions, meetings and social displays. The cathedral spreads its protective span over a community of free individuals.

3 Nature, space and reality in Renaissance art

SPACE IN LANDSCAPE PAINTING

For the first treatment of convincing landscape in Renaissance painting we have to look to northern Europe and to the paintings of the van Eyck brothers. As has already been said it was among artists north of the Alps that a closer observation of nature became habitual. Like the brothers from Limbourg who had illustrated the *Très Riches Heures* for the Duke of Berry (page 11), Jan and Hubert van Eyck were from Flanders.

In a manuscript which one of them – or both – illuminated around the 1420s, the *Turin Book of Hours*, we find a true landscape painting. This is not made of separate elements somehow inter-locked to fill up the composition. Rather it consists of an actual picture of a river bank surrounded by green wooded hills, where a castle and smaller houses recede diminishing into the distance. In the foreground the Baptism of Christ is taking place. In the middle

Jan van Eyck, detail from *Très Belles Heures de Notre Dame*, c. 1422–4, page size 28 × 19 cm, Museo Civico, Turin.

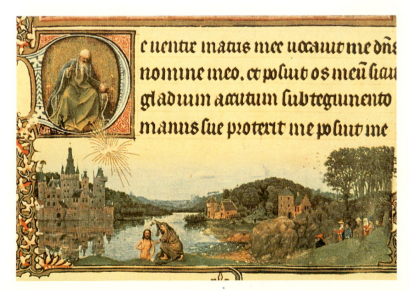

29

distance a group of ladies and gentlemen seem to be going about their country walk, while far in the background a low horizon, its blue paleness revealing how distant it really is, echoes the blue reflections of the water. A new fidelity to nature is revealed here. The artist's intention is to render an experience of nature, with people moving through it, with the events of the 'Baptism of Christ' and 'the gentlemen's country walk' taking place simultaneously yet apart in space as if unaware of each other's existence.

What these two events share is the evening sunset; the last heat of the sun warms equally those in its path. The artist who painted the little scene has looked at nature and its low evening horizon, very very intently. He must have observed, looking into the distance, how the natural colours were affected by different light, how the blue of the sky pales the further away it is, from blue into pale blue, into grey-white and white. This variation of colour from blue into white is the effect of the air and distance interposing between our eyes and the object of our observation. It is simply an optical effect which, once noticed, led the Flemish painters to simulate things in the distance by altering the colour. The device came to be called aerial perspective.

We need only to compare this miniature with the fresco by Ambrogio Lorenzetti in the town hall of Siena to see how differently and more perceptively the van Eycks were looking at the countryside. In the fresco, for the first time in Italian painting, a recognisable landscape, the hills and fields outside Siena, had been painted. But though it occupied a vast area on the walls of the town hall, the fresco hardly gave the beholder any feeling of space. The people represented in it keep to the foreground, as indeed people did during the fourteenth century, keeping to the town or its immediate outskirts if they wanted to be safe. Countryside and wilder nature were dangerous. Siena opened the gates of its protective and fortified walls during the day; at sunset they were closed.

The van Eycks' landscape shows new attitudes of mind and new habits. The crusading wars, the increase in trade in Burgundy and England, and the increased exchange of ambassadors between the European courts to deal with all sorts of problems, encouraged new experiences. Jan van Eyck himself travelled extensively through Spain and Portugal on missions for the duke of Burgundy. So it was

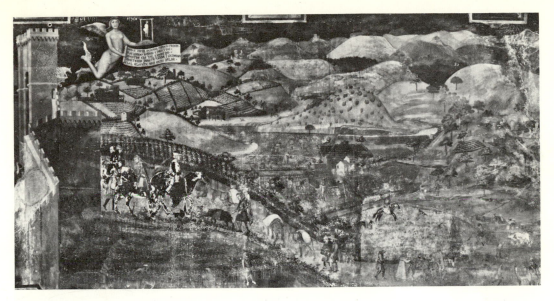

Ambrogio Lorenzetti, *Effects of Good Government*, 1337–9, detail from fresco, Palazzo Publico, Siena.

that side by side with the breathtaking visions of the chivalric society in Gothic art there grew plainer views representing another society: the intelligent and down-to-earth merchants, artists and craftsmen, well prepared to meet the demands of their trade or business. To them everyday life was a hard struggle. Now, instead of the flat gold or carpet-like backgrounds of Gothic paintings, distant views opened behind almost every scene whether interior or exterior. Seen through a window, balcony or portico, the familiar town squares and bridges, winding rivers or hills occupied most backgrounds of paintings.

The view behind the colonnaded portico of Chancellor Rolin's house by Jan van Eyck looks onto a town not quite identifiable, except for the tower of Utrecht cathedral appearing on the right. Otherwise the scene is made up of various elements from sketches of Jan van Eyck's travels still preserved in the Louvre. The artist was at pains to merge the foreground scene with the view in the background by a gradual treatment of the middle distance, a technical problem which took a long time more to solve. In this instance he has placed a turreted wall immediately in front of the view. This becomes very aptly a look-out post for the passers-by, who seem to use it to find out what is happening in the town. A new immediacy of story telling is added to the solemnity of the religious figures in the foreground. A simple human dimension breaks in as the painter abandons himself to the lyrical descriptions of the town stretching along the hazy waters of the river.

31

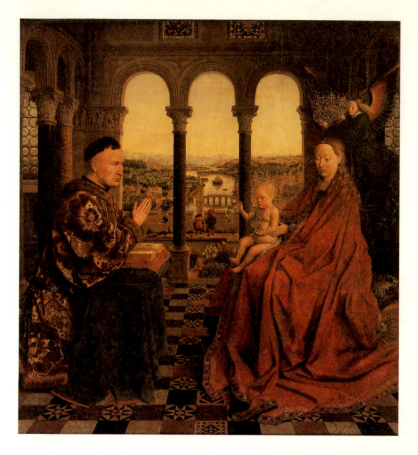

Jan van Eyck, *Madonna with Chancellor Rolin*, 1435, wood panel, 66 × 62 cm, Louvre, Paris.

This interest in vistas corresponding to actual places is best seen in a vista of Lake Geneva painted by Conrad Witz around 1444. In his *Christ Walking on the Water*, Witz represented a real view on the lake looking towards Mount Salève and still more or less recognisable today. The effect on the citizens of Geneva of seeing Christ walking on the quiet transparent waters of their own lake – the humble Peter and the other Apostles looking very much like some of themselves fishing from their little boats – must have been very striking indeed. They must have looked at Mount Salève in the background of the picture, their own sturdy mountain beautifully continuing the figure of Christ, and symbolising his force and stability. Vista or vision? For once the two were merged together.

Before abandoning the examination of these first examples of Flemish Renaissance art, let us open the panels of the Ghent altarpiece, another masterpiece by Hubert and Jan van Eyck, and gaze at the main scene, *The Adoration of the Lamb*. This vista of vistas opens in front of our eyes where 'Just Men and Holy Men, Bishops and Patriarchs, Holy Virgins and Knights' stand in silent

Conrad Witz, *Christ Walking on the Water*, 1444, tempera on wood, 132 × 154 cm, Museum of Art and History, Geneva.

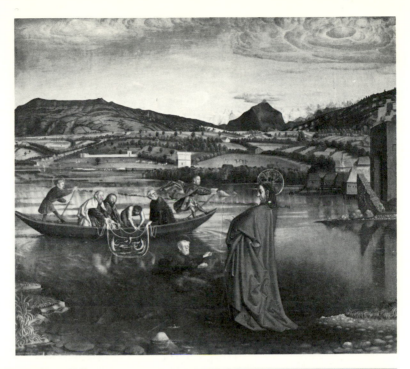

below

Hubert van Eyck, *Adoration of the Lamb*, *c.* 1432, detail from central panel, polyptych, 135 × 236 cm, St Bavon, Ghent.

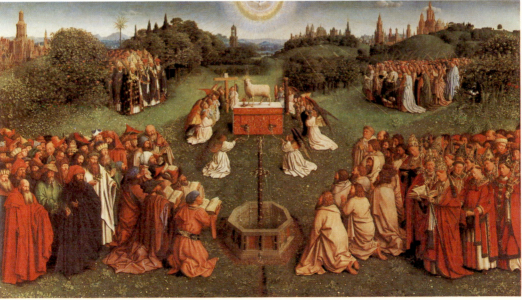

procession behind the apostles and prophets. Kneeling round the altar, at the climax of the composition, angels look up to the Mystic Lamb of St John's Gospel, the Lamb dripping blood into a chalice. Further symbols of Christ's passion and death are held by the

angels, isolated in a central zone where the green ground is darkened by their shadows silhouetting their fantastic wings. The ground all round is grassy, starred by small plants and flowers, enriched by formal bushes and trees. The costumes of the bystanders, the church vestments, staffs and mitres, the fountain in the foreground spilling onto the ground to form a bed of pearls, rubies and sapphires, all seem to tell us of a world of visions and fantasy. But in the distance St Bavon, the church for which the altarpiece was being painted, appears clearly outlined on the far right. Its recognisable slender towers and spiky pinnacles bring us straight back to reality. A historical, contemporary dimension is added to our understanding of the event. Behind the faces of the just and holy men we may even suspect the features of burghers from Ghent familiar to Jan van Eyck.

The green paths of the wooded hills of heaven, even if destarred and deprived of the gold light of revelation, reveal another mystery, this time a natural one: the paling of green into grey and white in the distance, the mystery of perspective.

SPACE IN PAINTED INTERIORS

At a time when the artist's understanding of perspective devices was still tentative, and interiors were often distorted, elongated, or set at an angle in order to fit in all the many elements of domestic life, mirrors reflecting hidden sides of a room, were often included. Whether they opened up the back or sides of a room, or a second room or a vista, they became another way of representing a many-sided reality, of heightening the visual experience.

In a work of the Master of Flémalle, the Werl altarpiece, we experience almost for the first time this multiplication of visual angles, points of view, openings onto different aspects of the real world. The donor and St John the Baptist, from a room with a window looking on the town, gaze through an open door at a very domestic representation of the Virgin. She sits with her back to a warm bright fire, with its light reflecting all round. Beyond her a window looks on a path winding towards the countryside. She is absorbed in her reading, unconscious of the door which opens in

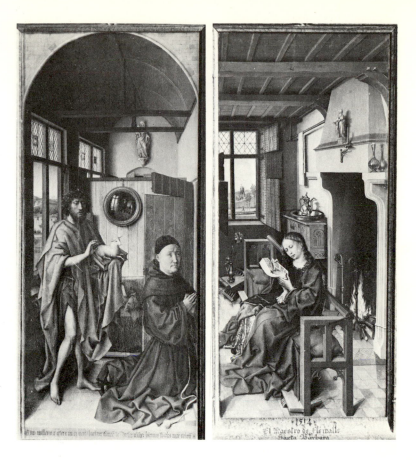

Master of Flémalle, *Werl Altarpiece*, 1438, each panel 100 × 47 cm, Prado, Madrid.

front of her and bathes her face with a dewy light. The donor and the saint are in turn reflected in a convex mirror which offers us their back view and another vista of their window on the town.

Was the device of the mirror, which we find over and over again in Flemish paintings of this period, a borrowing from the magnificent painting by Jan van Eyck of the Arnolfini wedding? Jan van Eyck and Robert Campin, the artist whom almost all historians believe to be the Master of Flémalle, certainly knew one another. They met in Tournai, for instance, in October 1427 for the celebration of St Luke, the painters' patron; Roger Daret and Rogier de la Pasture, the future Rogier van der Weyden, Campin's two main pupils, were certainly there. They must at least have discussed the new realistic style they all practised. Ideas and schemes for pictures may have been exchanged, motifs borrowed. We can imagine them rather like conspirators or reformers, conscious of looking at things in a new way.

Jan van Eyck must have known he was portraying things in a new way the moment he included himself in the background of one of his

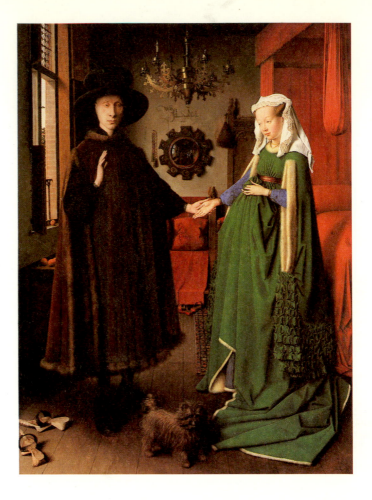

Jan van Eyck, *Giovanni Arnolfini and his Bride*, 1434, wood panel, 81.8 × 59.7 cm, National Gallery, London.

paintings. In *Giovanni Arnolfini and his Bride* two men are shown reflected in a convex mirror. One must be the artist since the inscription above the mirror reads 'Johannes de Eyck fuit hic 1434' (Jan van Eyck was here 1434). He must have realised that for the first time a painting took on a new value as a testimony of a specific private event.

How many levels of reality there are in this picture of a solemn moment of private happiness. This wedding alone, perhaps among the million vows lovers have solemnised to protect themselves against time and the frailty of human feelings, finds itself renewed every minute, every hour over the centuries, because of its vivid unforgettable pictorial representation. The artist took such care to preserve, as if caught between glass, the moment he was recording, the small informalities of an instant of life: the little dog's mouth shut tight holding in his bark, the couple's slippers casually left, the

fruit, the folds of the bed cover, the cushion just puffed; and all this reinforcing the artist's testimony that he was there – fuit hic – in that very moment when that most solemn vow was pronounced between Giovanni Arnolfini and Giovanna Cenami, his bride.

SPACE IN PERSPECTIVE DRAWING

Brunelleschi's handling of the problems of space in the many buildings he executed led him to devise a more concise and reliable manner of rendering space on a panel. As an architect and sculptor he must have needed sketches and designs to illustrate his projects and so realised how hard it was to give the effect of distances without a consistent system of perspective. In two panels painted around 1415 he applied for the first time a new, less empirical method of perspective called centralised, or one-point, perspective.

The panels, now lost, represented views of the squares, roads and buildings that could be seen from a door of Florence cathedral and from the main door of the Vecchio palace. Using the doors as frames to enclose his subject matter, the artist jotted down whatever was in front of his eyes. It seems that Brunelleschi covered the ground of the panel with burnished silver to obtain a mirror effect. On the panel he then outlined the buildings reflected there. He also translated all the visual distortions created by distance and angle, such as making things smaller the further they were from him. With this procedure Brunelleschi obtained a mirror image of the scene in front of him. Perhaps this is why he inserted a hole at the focal point of the composition and asked the viewer to look through it from the back, holding a mirror on the far side so that the painting was reflected in it. The beholder would then be able to see all the elements of the composition, neatly arranged, diminished or fore-shortened as they appeared to the artist when he stood in the doorway of the cathedral.

Many more adjustments, taking into account the laws of optics, must have followed. Eventually what Brunelleschi achieved was 'a complete, focused system of perspective, with mathematical, regular diminution towards a fixed vanishing point'.

The importance of such a discovery hardly needs to be stressed.

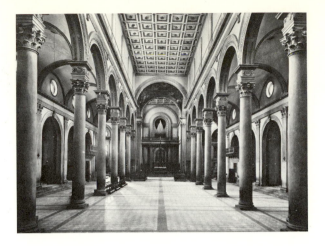

Filippo Brunelleschi, nave,
San Lorenzo, 1420s,
Florence, view looking
towards the altar.

The representation of space is a key problem for the painter who wants to convince the spectator of the reality of his representation. Things in life exist in space. Space has to be convincingly simulated if pictures of things and people are to appear real.

All through medieval times attempts at perspective, the science of simulation of space on a flat surface, had been practical and intuitive rather than scientific. But now a 'scientific' method of perspective which laid out specific rules was offered to the painter. In Alberti's little handbook, *On Painting*, which the Florentine architect friend of Brunelleschi compiled in 1433 for the Renaissance painters, the rules were laid out clearly and scientifically.

A logical and methodical solution had been found to the problem of creating space in painting. It was a man-made solution, to illustrate from man's point of view a natural world of which he is 'centre and measure'. The other name given to one-point perspective is artificial perspective, because it was created by man's mind. Not tamed but interpreted and understood, the study of nature was becoming a science.

If one looks from the central door of the church of San Lorenzo in Florence into the nave with its rows of slender corinthian columns, one cannot help feeling that Brunelleschi was translating his per-spective theory into three-dimensional terms in a building. In this church, built under the patronage of Cosimo de Medici in the 1420s, the columns recede into the distance and seem to diminish with geometrical precision. All lines seem to converge towards the main altar. The coffers of the ceiling, with perfect rhythm, move forward as if accompanying the steps of the beholder in his earthly journey towards heaven. When we stand by the doorway and look towards

above
Fra Angelico, *Presentation in the Temple*, c. 1434, detail from predella of Cortona triptych, tempera on wood, 23 × 230 cm, Museo del Gesù, Cortona.

above right
Filippo Brunelleschi, Sacristy chapel, San Lorenzo, c. 1420, Florence.

the altar, San Lorenzo is like a panel painted by its artist. But its real space is experienced when we actually advance into its depth.

From a chapel in the Sacristy of the same church, Masaccio drew the inspiration for *The Trinity* he painted in fresco in Santa Maria Novella (page 1). In this chapel, the space, divided over and over again in cubes and domes, presented itself so clearly to Masaccio, that even at a time when centralised perspective was but an experiment by the few, the painter could create a masterpiece of perspective foreshortening and visual shifts.

SPACE AND ACTION IN THE RENAISSANCE RELIEFS

There is no better example of how useful one-point, or centralised, perspective could be to the artists for suggesting space than the early panel of the *Dance of Salome*, by Brunelleschi's friend Donatello. The bronze relief is one of six surrounding the basin of the baptismal font in Siena cathedral. The other panels by Ghiberti, Jacopo della Quercia and others, show various stages in the development of the handling of space and narrative. Each artist stated his own position in the face of the new theories by choosing a more or less realistic and animated depiction of events. On the whole the more realistic and dramatic the narrative, the less subtle is the surface treatment, and harmony of line is sacrificed. The artists who were attracted to the new spatial techniques introduced bold lines cutting at right angles to the picture across plane after plane. These planes, like consecutive pages in a book, were each clearly devised to suggest broad areas in which the characters moved. Donatello's relief represents a high

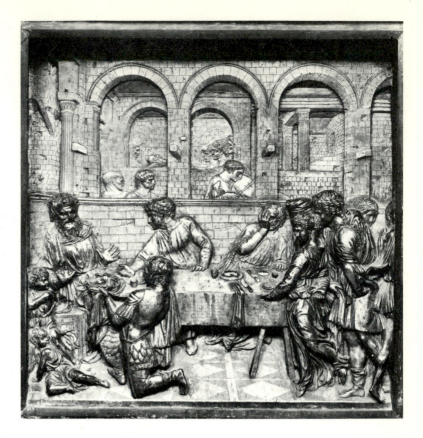

Donato di Donatello,
Salome, c. 1425, bronze
relief, 60 × 60 cm,
Baptistery font, Siena
cathedral.

point in the creation of space and in intensity of narrative in Early
Renaissance relief sculpture.

First of all the choice of the episode to illustrate the story could
not be more dramatic. Herod's banquet and Salome's dance are in-
terrupted by the sudden appearance of a soldier carrying the severed
head of St John on a platter. The zig-zag lines of the bodyguard, who
falls to his knees, his limbs still quivering in the sudden movement,
are at the end of a vertical line that continues through the guest at
Herod's left, and the pillar by his head, and leads straight to the
hall's ceiling. The hall, vast and high, at least twice the height of the
taller figure in the foreground, is framed by open arches revealing a
series of interiors. The two arches at the right and left of the pillar
frame the other essential elements of the story. Behind and at the
right, after the musical episode of the little band playing unaware
and undisturbed – a necessary relief from the high-pitched drama of
the foreground – three figures are presented with the evidence of the
abominable deed. Two of them look up astonished and still; only the
woman in the centre seems to pretend to a certain casual look as she

40

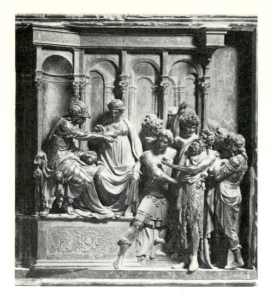

Lorenzo Ghiberti, *Imprisonment of St John*, (above) and *The Baptism of Christ*, 1427, bronze reliefs, 60 × 60 cm, Baptistery font, Siena cathedral.

tilts her head diagonally, just avoiding looking at the saint's head. Is this Herodias, the inspirer of Salome's request? Through the other archway the head of St John, this time lifted up by the guard, echoes the foreground scene and brings us back, through the musicians, to the horrified figure of Herod. The crowded group of guests, and Salome herself balance, with their thickly lined drapery and heavy detail, the intense emotion of Herod's group.

Somehow, looking at the scene, reading the story from front to back and finally returning to the foreground, we feel as if we have crossed the various halls, and know what Herod's palace is like. We have lived through the events quickly, ending up there, where the two little servants are, and competing with them for the same way out! To the poignant telling of the story, space has definitely added another dimension.

By comparison Ghiberti's *Imprisonment of St John* is mild and ineffective. His spatial treatment is more a demonstration of his awareness of modern perspective solutions than a real attempt at elaborating a setting. The characters crowded onto the foreground in no way appear to use the space suggested. The only one who dares to do so, the bearded man behind St John's arm, pays dearly for his attempt, squashed as he is between column and pillar. In fairness we must say that this work, planned by Ghiberti, was executed by studio assistants, which perhaps explains some of its awkward passages. In another relief, *The Baptism of Christ*, Ghiberti comes much more into his own. Here the magnificent smooth handling of

his figures in very low relief, all kept mostly on the same plane, picks out gleaming reflections which emphasise that the foreground is a bronze surface. The elegant flowing lines of the angels' robes start a pattern which is continued by Christ's and St John's drapery. The main characters are therefore linked together by a linear pattern. The atmosphere of the lower part of the relief is reflected in the higher section, which is actually tilted to pick up and reflect a continuous and almost transparent light. This endows the scene with a dreamy, celestial quality in which angels, God and dove seem to appear and to dissolve, true to their character as apparitions.

It is interesting however to compare this panel with Donatello's marble panel of the Ascension. We can then understand better the different intentions of the two artists. Donatello's motives are naturalistic and human; Ghiberti's are spiritual and symbolic.

In *The Ascension*, executed around 1428, Donatello used the *stiacciato*, a technique of extremely low relief. In this case the deepest undercut is no more than 8.5 millimetres. What Donatello really did by using this technique was to reduce his marble to a panel. He had therefore to use the same effects as a painter. Light and shade, if not colour, became the means by which he could suggest solids and spaces; perspective was his means of rendering distances. As the third artist of the initial group of Florentine innovators (with Brunelleschi and Masaccio), Donatello here showed himself not only as the great sculptor and artist, but also as the daring innovator and magnificent craftsman.

The Ascension is a symphony of luminous, atmospheric effects. The incident of the giving of the keys to Peter is merged with Christ's appearance to Mary and the apostles. This takes place on top of a mountain, whose slope at the back is indicated by the line of the trees disappearing low down. On the left a continuous line of hills leads our eyes into the distance towards Jerusalem.

It is not an easy work to appreciate unless we take time to savour it and take in slowly the subtle formal language used by Donatello. In the *Dance of Salome* the spatial planes are clearly defined and separated one from the other with the help of crisp three-dimensional details, like the firm undercut of the archways or the wooden beams protruding from the pilasters. These devices are now abandoned in favour of soft atmospheric transitions. The planes are there, each

Donato di Donatello,
Ascension, c. 1428–30,
marble relief,
40.6 × 114.3 cm, Victoria
and Albert Museum,
London.

clearly understood and skilfully used by the artist who places each
character exactly in its own space, but they merge almost impercep-
tibly with one another. Furthermore the use of the very low relief
reduces each plane to an almost transparent veil. Each plane is like
the petal of an unopened bloom.

Yet looking attentively at the hills undulating towards Jerusalem
one senses the vastness of the setting. The trees at the left of the
apostles plunge downhill from the summit on which the event is
taking place. By their decreasing size and sharpness they reveal the
air and distance which envelop them, and blur their outlines with
the horizon. The angels emerge from the soft transparent clouds and
float gently in mid air, moved by the same breeze that ruffles the tree
tops. Mary and the apostles, astonished and bereaved have yet an
aura of excitement which quietens down in the figure of Jesus, the
focal point of the composition. In him all the elements converge
according to the rules of centralised perspective.

In this work Donatello puts the seal on all the Early Renaissance
attempts at the conquest of nature and reality. In a unique hymn he
reaffirms both nature and human life in the miracle of Christ's
rebirth into heaven.

4 Patrons and artists of the early Renaissance

PAINTED PORTRAITS: FROM DONOR TO SITTER

Renaissance man is now the centre of interest. Paintings reflected his world, buildings were planned on his measure, literature celebrated him for his achievements, his qualities, his activities great and small. The growing awareness of nature and preoccupation with human things, the building up of an ideal to which man should aspire by bettering his mind and body, inevitably increased the sense of individualism. Now the donor is no longer painted humbly kneeling outside the holy event as in Masaccio's *Trinity* (page 1). The patron has himself placed firmly in the centre of the picture.

Chancellor Rolin (page 32) kneels in van Eyck's painting almost 'taking up a position' *vis-à-vis* the Virgin. Staring, more than adoring, his powerful personality is projected from the strong features, the penetrating eyes, the stubborn lines between eyes and nose. Suave, precious and beautiful, the Virgin belongs still to the world of Gothic imagery, while the chancellor is wholly within the realistic world of Renaissance portraiture. No longer simply the donor, he has now become the real subject of the painting.

After the second decade of the fifteenth century portraiture blossomed in Flemish art in a series of masterpieces where close attention to realistic details was kept in check by sober backgrounds perhaps derived from medieval fashions and styles of life combined with the symmetry and regularity of classical inspiration. Van Eyck's *Man in a Red Turban* or his *Madonna of Canon van der Paele* are great examples of this type of early realism, while the contemporary works by Rogier van der Weyden and Petrus Christus, such as van der Weyden's *Portrait of a Lady*, represent the more idealised type of realism that we call 'classical'. (The term classical is used here not to refer to ancient models but in its more general meaning of a composition based largely on horizontals and verticals so regularly presented as to achieve serenity and equilibrium.)

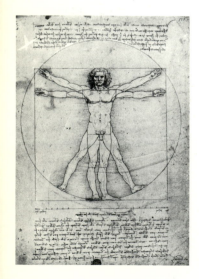

Leonardo da Vinci, *Vitruvian Man*, pen and ink, Accademia, Venice.

44

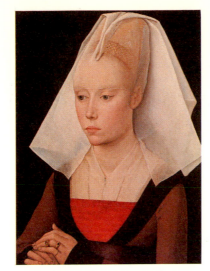

Rogier van der Weyden,
Portrait of a Lady, *c.* 1430,
wood panel,
36.2 × 27.6 cm, National
Gallery, London.

Looking at Rogier van der Weyden's portrait we find that each natural shape is represented by its perfect geometric equivalent. The portrait is endowed with a more detached, almost more abstract, quality than van Eyck's works, yet without undermining its realism. The firm horizontal of the lady's red bodice, the triangular and pyramidal folds of the headgear and camisole, all frame, with geometric precision, the mobile oval of face and forehead. The sense of volume is so strong that we want to touch it; the features all balance perfectly around the centre of the picture to give it a serenity and timelessness previously to be found only in Greek art.

The Flemish school of portraiture presented, for the first time in the history of European art, images of men and women which focused more and more on their aesthetic, spiritual and physical qualities.

Portrait bust of Cicero,
c. 50 B.C., Capitoline
Museum, Rome.

A stream of portraits in painting, sculpture and literature now followed one another in Italy, as they had done in the ancient world of Greece and Rome. Sometimes idealised, sometimes truthful to the point of crudity, portrait busts and medals, pictures or written descriptions perpetuated the Renaissance man. The new individual, still young, at times gauche, was searching for a special place in history, a role distinguished enough to be respected by posterity.

Vespasiano da Bisticci, the Florentine bookseller and manuscript-publisher, in his *Lives of Illustrious Men*, conjured up image after image of great men, virtuous men, belligerent men, men of learning, churchmen and statesmen. His writing followed, like

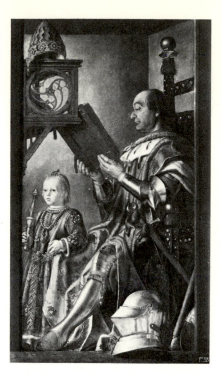

Justus of Ghent, *Federico da Montefeltro and his son*, *c.* 1477, wood panel, 134 × 77 cm, Ducal Palace, Urbino.

Plutarch's *Lives*, a literary tradition rooted in the classical past. The images of the greatest characters of the Renaissance fired the imagination of the reader and evoked the wonder of the historian. Their real everyday life may not have been reflected exactly in such glorious accounts. The perfect oval of Rogier van der Weyden's *Lady* may not correspond exactly to the bones in her face, yet the original did provoke the artistic product. Something in her inspired the artist to sense and create perfection, just as something in those Renaissance men, perhaps their aspiration to virtue, inspired a humanist bookseller to see them as 'illustrious'.

The image of men and women conjured up by the society's ideals was brought to being by the teaching of parents and tutors alike. Most of Vespasiano's illustrious men had attended the same school, the Casa Gioiosa (or House of Joy). The Gonzaga family, lords of Mantua, had founded it in 1423 under the direction of Vittorino da Feltre, a well-known teacher of Greek and Latin who had previously taught in Padua and Venice. Da Feltre was invited to Mantua by the Gonzaga, largely in the hope that he would instruct their numerous children. The school however was open to a wide public, even providing free board for people who could not afford the fees. The Montefeltro of Urbino, the Este of Ferrara, the Sforza of Milan, the

46

Malatesta of Rimini, in other words most of the future rulers of the Italian states were brought up in the Casa Gioiosa or a few similar schools.

The school was organised in imitation of the ancient Greek schools and equal time was devoted to learning and physical education. Coeducational and residential, the school educated the second generation of the Italian Renaissance rulers and their wives. Once they came to power humanism permeated all Italian society together with those qualities of idealisation, sophistication and elitism which flowed from such a demanding discipline of mind and body.

FROM MERCHANT TO LORD: COSIMO AND LORENZO DE MEDICI

It is interesting to follow in Florence the development in Renaissance man from individual, to ideal man, to lord within one family. Cosimo de Medici was a highly individual character. From being the son of a small merchant he rose to the highest position in Florence by building up his own business. Although he could be tolerant of other individuals he made no pretence of any other motivation than his own ends.

'Now it seems to me only just and honest that I should prefer the good name and honour of my house to you: that I should work for my own interest rather than yours. So you and I will act like two big dogs who, when they meet, smell one another and then, because they both have teeth, go their ways. Wherefore now you can attend to your affairs and I to mine.' These words in Vespasiano da Bisticci's *Life of Cosimo* sum up the mercantile attitude to a political opponent.

In a way this concentration on looking after his own family interests, while permitting others to look after theirs, goes a long way to explain the variety of styles that co-existed in the Early Renaissance in Florence. So too does the patron's lack of interference with the artist's ideas of subject matter. The patron simply produced the money and a minimum of advice on the purpose of the project. The artist followed his own inspiration. Great art and great artistic personalities flourished in this freedom especially as a sense of purpose and moral obligation to high standards was already present in the philosophy of the time.

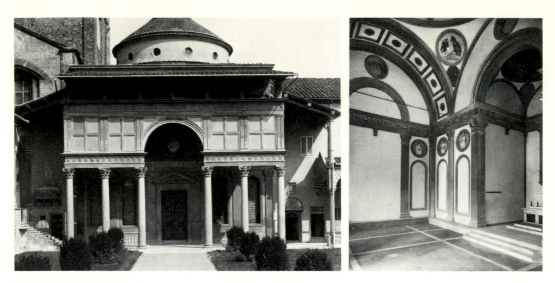

Filippo Brunelleschi, Pazzi
chapel, *c.* 1430, priory of
Santa Croce, Florence.

The down-to-earth mentality of Cosimo, a far more generous and
just man than his words would lead us to believe, was reflected in his
style of life and in the works of art inspired by him and his
philosophy. Brunelleschi built churches more and more measured
to man's proportions, almost as if for his better comfort. This com-
fort and ease of approach were based on a more direct, more equal
relationship between man and God.

The Pazzi chapel, which Brunelleschi built as a chapter house for
the priory of Santa Croce is a good example of this. It offers a clear
interpretation of the space contained within its walls; their division
into zones is clearly picked out by the flat decoration in grey stone.
The geometrical design of the whole emphasises the clarity and
practicality hoped for in the decisions of the chapter.

The famous façade of the Pazzi chapel, resting slender and agile
on the six corinthian columns, is a model of elegance, decorative
restraint and subtle manipulation of spaces. It too exemplifies the
Early Renaissance feeling for clarity and simplicity, order and
measure, in mind and body. The artist has divided the façade into a
series of squares related one to another by their geometrical
proportions. One square is the area formed by the three columns at
the side of the central archway. The area immediately above it and
resting over the entablature is in turn subdivided into squares – the
lower ones panelled, and the upper ones open, forming the terrace
under the roof. The lower squares of this zone too are subdivided
into four panels. The side of one of these panels is what is called the
golden ratio of the building, that is the unit of measurement which

divides exactly into any other part of it. The dome, which almost seems to float on the cylindrical base of white stucco, finishes the building with consistent elegance and restraint.

The Pazzi chapel makes a perfect conclusion to Brunelleschi's early style. Here, as in the Innocenti Hospital, the light playing on the façade contrasts with the darkness of the portico and brings out the slender outline of the columns. Soon, though, Brunelleschi was to move towards a more massive style in which the linear elements of his architecture would be replaced by more three-dimensional ones. The church of Santo Spirito which he planned in 1434 and modified in 1444 before his death in 1446, is a fine example of his more robust, weightier manner.

In the same way the frugal, rational aspects of early Renaissance Florence were soon to change. The long period of peace enjoyed by Florence under the hidden but all-pervading leadership of Cosimo had increased the town's wealth and the personal fortunes of the leading families. The successes in banking and the powerful relations developed with popes, princes and kings turned the next generation of Medici from merchants into lords. Piero, who succeeded his father as head of the family on Cosimo's death in 1464, was greatly admired and loved by the king of France, Charles VII, who allowed him to add the lily, the royal French emblem, to the Medici coat of arms. It was Piero who hunted out manuscripts and old remains to create the famous Medici library and collection, still housed in the building later designed for it by Michelangelo. Piero died in 1469 and his son, Lorenzo, (1449–1492) succeeded him.

Lorenzo, the real embodiment of the change in style and attitude of the House of Medici, appears as a young man of twenty in a painting, *The Journey of the Magi*, by Benozzo Gozzoli. Richly attired and aristocratic, he rides with the other members of the family, between the patriarch of Constantinople and the last king of Byzantium (who had visited Florence in 1439 for a meeting between the Christian Churches of East and West). Looking more aristocratic than the king himself, Lorenzo the Magnificent thus entered the scene of European politics and courtly splendour.

A new aristocratic way of life, full of stately celebrations, tournaments and gay carnivals, full of refinement of fashion and manners shone forth in the last decades of the fifteenth century in

above
Andrea del Verrocchio,
Cosimo de' Medici, marble,
height 36 cm, Staatliche
Museum, Preussischer
Kulturbesitz, W. Berlin.

above right
Benozzo Gozzoli, *The
Journey of the Magi*,
c. 1469, fresco, Medici
Palace, Florence. Detail
showing Lorenzo de'
Medici.

Florence. And yet in 1469, in the tournament for his engagement,
when Lorenzo had just taken leadership of the family after his
father's premature death, he chose for his own personal emblem 'a
green shoot just born on the trunk of a dead laurel tree' with the
words, '*Le temps revient*', 'the time is coming again'. Did the
Magnificent hope, for a moment, to return to that old, frugal
ordered mercantile society?

THE COURT OF URBINO: EQUILIBRIUM ACHIEVED

It was in Urbino, the small duchy in the heart of the Apennines, that
the Early Renaissance attempt to achieve a new order and harmony
in life as well as in art, found its most perfect expression. Federico da
Montefeltro, statesman, warrior, and lord of Urbino, had been a
pupil of the Casa Gioiosa. He embodied not only the qualities of
education and refinement essential to a Renaissance leader, not only
the taste and visual culture to appreciate the new artistic achieve-
ments, but a magnificent '*umanita*' – a human sensitivity, for which
his biographer, Vespasiano da Bisticci, praised him over and over
again. Federico, the great *condottiere* respected by all Italian rulers
for his magnanimity as well as courage, was made duke by Pope
Sixtus IV and endowed with the Order of the Garter by Henry VII
of England. Vespasiano said that Federico united in himself all the
Renaissance ideals of physical valour, mental distinction and true
Christian spirit. His religious sincerity, his sense of equilibrium and

50

measure were described in a series of episodes where we read of the lord of Urbino in familiar intercourse with his people, in the market square or in the streets of the town, in his palace – where any citizen could ask for an audience at any time – or in his study with his beloved books.

No wonder the artists he chose to build the finest Italian Renaissance palace, his ducal dwelling in Urbino, were Piero della Francesca, Francesco Laurana, and Francesco di Giorgio Martini; three of the most serene, assured and balanced artists of the whole century.

In the paintings of Piero della Francesca, the Florentine preoccupations with the rendering of reality and space, movement and immediacy in story telling, found a definitive solution. Piero worked in Florence in the 1430s and returned to his native Borgo San Sepolcro in the 1440s. The *Madonna della Misericordia*, commissioned in 1445, makes us think that the strains and tensions of Brunelleschi's perspectives, Masaccio's volumes and Donatello's realism had not been in vain (page 52). They have found their true synthesis in the effortless realism of Piero's art. The round golden arch of the frame echoes the Virgin's cloak as it opens like a dome to receive the believer. She appears more than real, more than present. She is beautiful yet makes no concession to prettiness. In her perfect symmetry, her timeless features and forms, the Virgin shelters and protects the believer. The inhabitants of Borgo San Sepolcro must have felt secure in the breadth of her embrace. It is as if, like the dome of Florence's cathedral, she could embrace all people. This new reality of Piero della Francesca has no doubts; it needs no verification; it just exists.

The love of Federico da Montefeltro for law and order, a love which he passed on to his subjects, eventually found its visual expression in the ducal palace. On one side the palace rested on the steep flank of the Apennines with enchanting vistas of the valley's green pastures and curving waterways, but also easy access to enemy troops. So it needed on this side to be well fortified. The architect provided an impregnable lower bastion thrusting proudly towards the valley, while above he planned a series of elegant arched balconies. The harsh silhouette of the bastion merged softly into the palace façade. Through the balconies the early dawn and azure light

Ducal palace, Urbino,
courtyard and study.

below
Piero della Francesca,
*Madonna della
Misericordia*, *c.* 1462,
wood panel, 273 × 325 cm,
detail from altarpiece,
Palazzo Communale,
Borgo San Sepolcro.

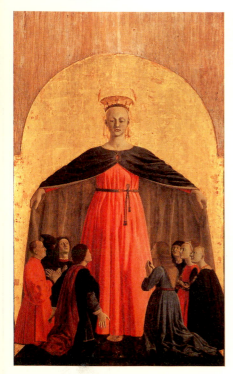

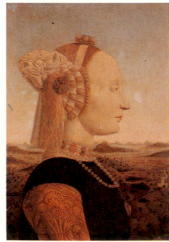

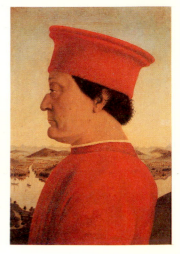

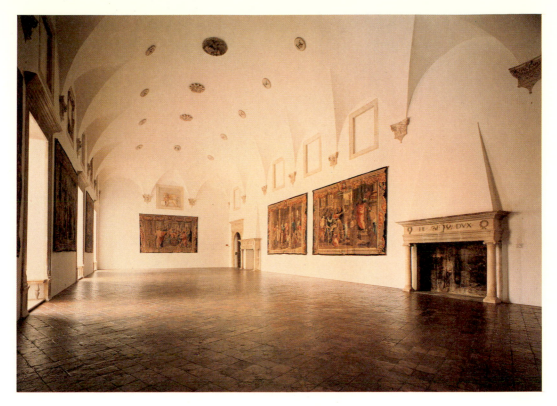

Ducal palace, Urbino, hall.

of the Apennines bathed the exquisite interiors of the duke's dwelling. On the town side plain walls, squared corners, windows picked out in marble, and geometrically designed recesses linked the palace façade to neighbouring buildings and formed small intimate squares, almost parlours, which created ideal settings for local ceremonies or outdoor performances, shared alike by court and townsfolk. Inside, carved doorways and round arches lead through vaulted corridors into the famous courtyard: Laurana's Renaissance masterpiece of architectural purity. Around the courtyard, the four floors of the living quarters are arranged in a series of halls, rooms and stairways all inspired by the classical tradition. In these beautifully proportioned halls, directly opening from one to the other without dark passages or treacherous corridors, one moves from light to light in a clarity of body, mind and spirit.

Into this luminous court moved the Renaissance courtier made famous by Castiglione's book, *The courtier*. He was a man who needed to be well bred, of refined taste, with an ease of manner, combined with a capacity for manly pursuits, a knowledge of the classics, an acquaintance with history and philosophy, an appreci-

53

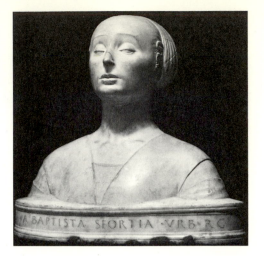

Francesco Laurana,
Battista Sforza, *c.* 1474,
marble, height 50 cm,
Bargello, Florence.

ation of music, painting, architecture and sculpture, a connoisseur-
ship of the rare and the beautiful whether books, jewels, coins or
scraps of antiquity. All these interests should be borne lightly,
without pedantry or excessive professionalism.

A group of works of this period, all connected in some way with
the Montefeltro, seem to share what one could call 'the Urbino
character'. This is a luminous serenity combined with a realism free
from unbecoming blemishes though never to the point of altering
the truth. For example Piero della Francesca's diptych with the pro-
file portraits of Duke Federico and his wife, Battista Sforza rendered
the noble ducal figures truthfully, if not beautifully. On the back of
the panels, their triumphal chariots move in the recognisable valley
and hills, celebrating the arts of warfare and domesticity which the
two sitters embodied in life. The greatness of these paintings is
apparent in the utter lucidity, unhesitating lines and clear images,
silhouetted against that serene and luminous countryside.

At this point Renaissance society was directed in a combined
human and artistic effort towards humane and classical ideals of
thought, fashion and style. The extent to which it achieved these can
be judged in the examples of art and life left for posterity – illus-
trious art, but truthful also, reflecting the reality of their lives.

5 Tensions and experiments at the end of a century

The discoveries that marked the beginnings of Renaissance art were the work of a few artists. By the middle of the fifteenth century, the movement had been enriched by many more contributors and its influence had spread throughout central Italy. Two main directions can be recognised in this growth. One followed the more tentative, inventive and experimental art of the Florentines: Brunelleschi, Masaccio and Donatello; the other the art of Piero della Francesca, from which would spring the Umbrian School, the serene art of Perugino and the perfect art of Raphael.

All the artists however, declared, at least in theory, their allegiance to an art which observed the rules of nature and was inspired by classical art, the only art from the past which they recognised as based on an admiration for man and nature similar to their own.

From Uccello, the greatest exponent of perspective, to Fra Angelico, the Dominican friar whose frescoes in the convent of San Marco show scene after scene from the gospels in delightful Brunelleschian settings full of the purest and most fervent religious feeling; from Filippo Lippi, the painter of the most enchanting Madonnas and babies, almost too alive with an unsuppressible *joie de vivre*, to Luca della Robbia, Desiderio da Settignano or the Rosellino brothers, sculptors who continued the great achievements of Ghiberti and Donatello, all the artists followed the new manner.

But during the fifties and sixties innovations and experiments seemed to come to a standstill. The perspective landscapes of the Arno river which had so enriched the backgrounds of Lippi's Madonnas, became mannered imitations in Gozzoli's or Baldovinetti's compositions; the Madonnas and angels of Angelico and Luca della Robbia were imitated lifelessly in works devoid of feeling, depth or compassion. The next generation of the della Robbia family tried to imitate the religious compositions in glazed terracotta which Luca had made famous, only to produce easily saleable artefacts rather than unique works of art. As always after a

55

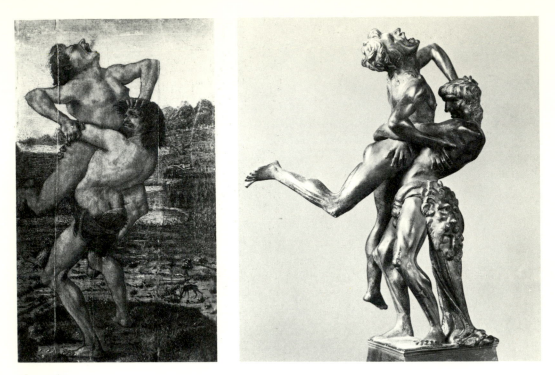

above
Antonio Pollaiuolo,
Hercules and Antaeus,
c. 1475, wood panel,
16 × 9.5 cm, Uffizi,
Florence.

above right
Antonio Pollaiuolo,
Hercules and Antaeus,
c. 1475, bronze, height
46 cm, Bargello, Florence.

period of excellence, a period of imitation and artificial mannerism, seemed to set in.

Then during the last decades of the fifteenth century a new spirit of invention sprang up in Florence, perhaps in response to the years when Lorenzo the Magnificent set the pace for a new, more aristocratic and sophisticated phase of Florentine culture.

THE ART OF THREE GREAT GOLDSMITHS: POLLAIUOLO

The first and the liveliest to search for new directions was Pollaiuolo, one of a family of goldsmiths and perhaps a pupil of Donatello and Andrea del Castagno. After his first work as a goldsmith, he turned to sculpture, painting and engraving. This variety of skills was not so much an aspect of the universality of the great Renaissance artist as of a need to experiment. Pollaiuolo seems to have wanted to try out various techniques and to test in works of metal what he had discovered in the illusionistic effects of painting.

He did this in *Hercules and Antaeus,* produced in both media around 1475. The strain and tension of two opposing forces, attacking and resisting, were explored and expressed through an agile and

56

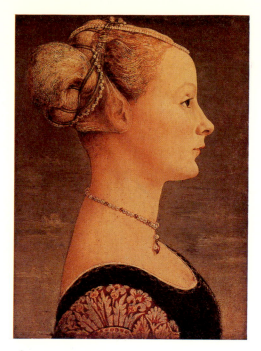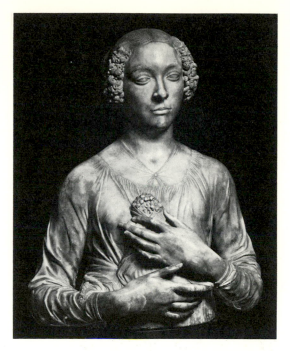

ever moving line, through contours that were precise but incessantly changing in direction. The lines of the landscape instead of converging towards a focal point behind the axis of the picture, exactly in the middle of the two bodies, seem to be thrusting outside the picture frame. Yet each work retains that searching quality of an artist's hand finding a new way. In the bronze the light quivers over the shining limbs and bounces back and away from them like waves of sound echoing after an explosion.

These incisive searching lines which will dominate Florentine art by the end of the century, can be traced again in one of Pollaiuolo's later masterpieces, the *Portrait of an Unknown Lady*. The artist's search has moved from the tensions of movement in relation to space towards the tensions within the human anatomy itself. The unknown sitter, even though presented in the classical profile pose, is fully alert, responding to the artist's presence. Pollaiuolo has caught her quick sensitive response in the upward thrust of her slightly curved back continued in the opposite curve of her neck. The line then follows her capricious indented profile, from the receding lower lip into the determined chin. Its angles are echoed by the triangle of the veil pulling back her ears and holding the decorative headgear. Pollaiuolo's silverpoint seems to cut into the lady's

features in somewhat the same way as a profound psychological analysis might cut into the human spirit.

This new way of exploring the more dynamic aspects of human experience, of trying to find subtler and subtler ways to express its transience, pointed to a new maturity in Renaissance society. Having learned all about the physical world, they were looking towards the spiritual and the way it manifested itself by a change of attitude and actions.

Shifting lights and directions captured the most imperceptible moods just filtering through a sensitive face. The most delicate fabrics could hardly conceal the veins pulsating on a woman's neck, or the beat of the heart under the breast. All these devices became new means of expression for these 'artists of the imperceptible'.

VERROCCHIO

Andrea del Verrocchio clearly showed to which period he belonged in that most sensitive of marble portraits the bust of the *Lady with the Bunch of Flowers*, made about 1480. Once again silhouetted in classical pose, this time frontally, the sitter breathes under the light which plays on the delicate modelling of her head, on the fine sensitive hands, on the varied thickness of her tunic and camisole. Her face, bathed in the light, and brighter by contrast with the opaque curls thickly bundled around it, echoes the light on her breast and the shadow of the bunch of flowers clinging to her neckline. If we compare her to Laurana's bust of Battista Sforza or Piero della Francesca's portrait of the same sitter (page 52) we can see that we have moved into a different epoch.

Verrocchio, like Pollaiuolo, had also started as a goldsmith, but his artistic personality soon exceeded the small scale of that art. The future teacher of Leonardo, Lorenzo di Credi, Perugino and Botticelli, showed the originality of his approach in an early bronze work for the Medici, the tomb of Giovanni and Piero, sons of Cosimo.

To appreciate this we need to look first at one of the best examples of a humanist tomb, the monument to Carlo Marsuppini, Chancellor of Florence, by Desiderio da Settignano. There a perfect round

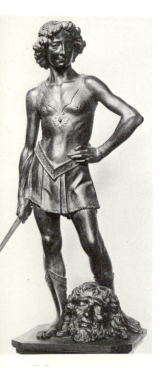

arch provides the architectural setting for a classical sarcophagus and a virtuoso display of figurative sculpture. Verrocchio, however, presented a more spiritual interpretation. For him the recessed archway became just a stone door-frame, very much like the marble ones in a Renaissance palace. Long trellises of foliage and flowers still appear, with climbers at the corners to symbolise the return of the body to the earth, while the soul reaches towards the sky. This motif is accentuated by the rich acanthus leaves sprouting from the centre of the tomb and the two cornucopias tumbling out fruit and flowers. The classical symbolism of the earlier tomb was completed by Verrocchio, in the netted screen reaching towards the top, as if accompanying the soul in its effort to reach its creator.

The tomb, where the strong decorative carving captures and releases marvellous plays of light and shade, should not be shown against closed shutters, but open to the light and air. In this monument, the love of symbolism which was characteristic of the court of Lorenzo the Magnificent, found one of its finest visual expressions.

It was in Verrocchio's *David* however, that the elegance of Lorenzo's court with its refinement and sophistication was most intensely expressed. David, agile and slender, sensitive of face, his elegant limbs just covered by the fitted armour, appears more as a page of the Medicean court than as the humble young hero of the

Israelites. His weight, thrown on one leg in the classical manner, holds his body in tension. Each limb moves in a different direction; the sword moves away from his body; the shoulders and neck turn to right and left; the bones of the neck are tensed in the sudden twist of the movement; all this conveys a sense of anticipation. The light can glide, stop, start again, on the smooth shiny surfaces of the young body. Everywhere there is nervous energy. Whereas in the *Lady with the Flowers*, the hair bathed in golden light gives the effect of shadow on the face, here the light mercilessly floods Goliath's features in the last grimace of physical pain.

If the young Leonardo da Vinci was the sitter for this composition, as is sometimes suggested, what a fine portrait we would have of the youthful genius, ready to challenge life.

BOTTICELLI

The third artist of the group, Sandro Filipepi called Botticelli, also created his figures with well-defined contours, but from the start he set them in vivid reaction to the rest of the composition.

In *Judith*, one of his earlier works, Botticelli depicted the physical incidents of the chosen story in such a way as to reveal the inner feelings of the heroine. The two women hurry down a hilly slope, the maidservant almost running to keep up with her mistress's swift advance. Their tunics are blown back by a strong wind, which bends the top of a half-concealed tree as well as the olive branch, emblem of the peace Judith has brought to her people by slaying Holofernes. Still in the shocked stupor of the atrocious deed she has accomplished she begins to realise how painful its execution was. Her gentle features, taut in the pride of youth and health, reveal a sudden maturity. The eyes, sad and lined, seem to show that smiles have gone for ever from her heart. The servant, sturdier in features and feeling, carries the precious trophy, but is perhaps worrying about her mistress. Down in the plain, the Israelites storm out of their city gates in a surprise attack on the enemy they now know to be leaderless.

The small panel, together with its companion piece *The Discovery of the Dead Holofernes*, was painted in the delicate, exquisite technique of the former silversmith. Rich and ornate as it is in the details of the clothes and ornament, the overall effect is one of extreme

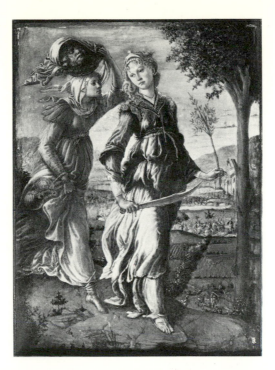

right
Sandro Botticelli, *Judith with the Head of Holofernes*, *c.* 1470, wood panel, 31 × 24 cm, Uffizi, Florence.

below
Sandro Botticelli, *Primavera*, *c.* 1478, wood panel, 203 × 314 cm, Uffizi, Florence.

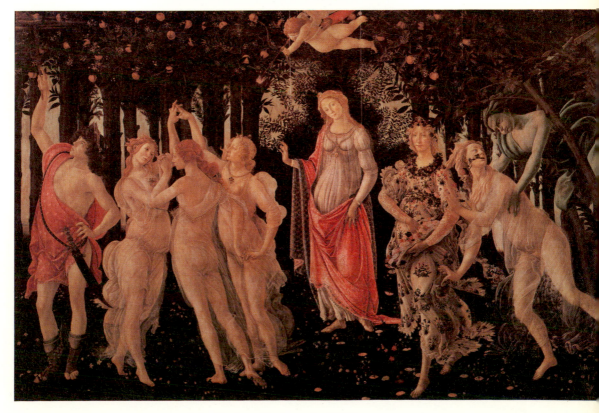

harmony and balance. The details combine to reveal the shock of the event. They also combine in harmonious composition, each motif echoing like notes in music. For instance, the oval line of Judith's forehead is repeated in her necklace and neckline. The serving maiden's scarf and shawl blowing in the wind, are echoed by the cloth floating from Holofernes' head. Botticelli's great skill in composing a picture appeared here in his early youth and was to remain as one of the main features of his art.

In his later pictures, *Primavera*, *Minerva and the Centaur* and the *Birth of Venus*, Botticelli showed something of the semi-religious, semi-fantastic world of Greek mythology popular at the time. In Lorenzo the Magnificent's court, culture, sophistication and refinement mingled with the moral and philosophical thinking of the scholars, patronised and befriended by Lorenzo himself. All this found expression in Botticelli's painting.

He was himself a member of the Medicean circle. In the 1470s Lorenzo had introduced him to Politian, the humanist and poet who celebrated Medici festivities and tournaments with enchanting rhymes. It was above all in the works of these two artists, in the elegant sensuous verse of Politian, and the polished enamelled hues of Botticelli, that the strange bitter-sweet atmosphere of Lorenzo's world was represented. It was captured especially in one of the greatest examples of Botticelli's art, his painting, *Primavera*.

The Three Graces, fresco from Pompeii, National Gallery, Naples.

In the garden of Venus, that garden of eternal spring and cloudless skies, orange trees surround the beautiful goddess. She, radiant and luminous, and framed by the green shadow of Venus's myrtle bush, supervises the procession of spring. From the right Zephyr, the early March wind that brings the first mild breaths to warm the earth, reaches to possess the nymph Chloris. Chloris unadorned and naked like the earth in winter, cries out in vain hope of escape. But only flowers appear from her parted lips. Then she reappears, transformed by spring into the richly attired Flora, a figure of triumph and opulence. The goddess Venus herself draws our attention towards her son, Cupid, ready to strike with his darts one of the three Graces. These are Venus's attendants, joined in the dance, but not for long. Cupid's darts will pierce their hearts. Mercury, the armed guardian of Venus's reign wards off some tactless clouds, that might dare to disturb the serenity of the spring procession.

The three Graces may be the clue to the composition. A recently discovered inventory of the town dwelling of Pierfrancesco, a cousin of Lorenzo the Magnificent, suggests that the picture was originally made for the master's bedroom. The room was refurnished for the young man's marriage in May 1478. As Botticelli's work belongs, by its style, to those very years, it seems likely that the work was commissioned for that occasion.

If this is so, the erotic character of the Graces in their revealing veils – virginity tempted by the arms of Cupid – would make a most appropriate theme for a marriage picture. Venus, the goddess of love, presides over the happiness of the union, ensuring an eternal spring for those who are in love.

This most poetical theme is worthy of the pen of Politian or Botticelli's brush. But who suggested it to whom? Could it have been an idea of Lorenzo the Magnificent himself? He had arranged the marriage of his cousin and his own rhymes contain many verses devoted to spring: 'When Flora with flowers the world endowes'. Whatever the classical and learned sources behind Botticelli's subject, the picture transcends all suggestions and is simply one of the greatest examples of Botticelli's art. But it also announces the end of a century.

Botticelli's spring procession even with the ravishing figure of the triumphant Flora, does not advance triumphantly. It dwells in still-ness even in the midst of its own progress. Is it actually proceeding or standing still? Is it perhaps trying to hold back the advance of spring, youth and happiness from their inevitable decline. 'How beautiful is youth that one loses on the way. Who so wishes, be happy now, for tomorrow is unknown', said Lorenzo the Magnificent in one of his most popular poems. Perhaps he felt the premonition of things to come.

Botticelli, the mature artist of the Medicean circle, seems to reflect the dissatisfaction permeating Florentine society before the turn of the century. Looking at the artist's works from now onwards, something of the vital quality of Pollaiuolo and Verrocchio seems to be missing, for instance in the lines picking out the rhythm of the Grace's dance. The line returning upon itself over and over again does not seem to find a way out.

Perhaps the youth of the Florentine Renaissance halts here.

Having reached the high point of its own momentum, it refused the only way out: its maturity. From now on Florence's greatest artists would have to seek for maturity elsewhere.

Even for the Medici themselves, the hope expressed in their motto, *Le Temps Revient*, seemed more and more remote. That time of rising hopes and certain goals, uninterrupted achievements and political conquests, which Florence had enjoyed under the leadership of Cosimo, was no more.

Under Cosimo's son, Piero, a series of bankruptcies had shaken the family businesses. In the 1470s they had lost papal favour and with it the mining rights near Rome and banking within the city. The Pazzi family's part in the assassination in 1478 of Lorenzo's brother, Giuliano, had taken away from Lorenzo and from Florence that sense of serenity and intellectual certainty that had marked the life and art of the Early Renaissance.

Only twelve years later Fra Savonarola's thundering sermons from the pulpit of Santa Maria del Fiore would denounce all that the Florentine Renaissance had stood for. Against beauty, culture and love of nature, the friar opposed simplicity and the love of God. Renaissance works of art and manuscripts were burnt. The men most active in executing the friar's orders were the ones who, after Lorenzo's death in 1492, exiled the Medici, ransacked their palace, and destroyed their art collections. Lorenzo's incompetent and conceited son Piero was partly to blame for these events. But perhaps more so was the Florentines' need for a greater share in government after fifty years of Medici domination; a need for self assertion and a search for a new identity in freedom. Both tendencies anticipated similar ones spreading all over Europe early in the sixteenth century.

6 The Renaissance in the north of Italy

Andrea Mantegna, *The Death of the Virgin*, 1461, wood panel, 54 × 42 cm, Prado, Madrid.

65

In a contract drawn up in Padua in 1467 between the painter Francesco Squarcione and the father of a prospective pupil we learn that the master will teach 'the system of the floor, well drawn in my manner: to put figures on the said floor here and there at different points, and to put objects in it – chairs, benches and houses; and he is to learn how to do these things on the said floor; and he is to be taught a head of a man in foreshortening ... and he is to be taught the method for a nude figure, measured before and behind ...'

It is interesting to find at this time in Padua the same concern as in Florence for spatial effects, for anatomy and foreshortening. In other words, the artists were trying to simulate reality in a painted image in such a way as to deceive the public into believing the picture to be more real than nature itself.

ANDREA MANTEGNA

Andrea Mantegna, the most famous pupil of Squarcione, must have had an active part in the development of the master's spatial techniques. He was apprenticed to Squarcione in 1441 and eventually adopted by him. Master and pupil must have learnt together from Donatello who had been in Padua from 1446 to 1456. Both in the bronze panel reliefs for the shrine of St Anthony and in the perfect measures and proportions of his equestrian statue of *Il Gattamelata*, Donatello had shown how classical proportions and innovations in perspective could come together. The impact of an artist like Donatello, so much at ease with the lessons of antiquity and yet so daring in finding new personal solutions, must have been felt acutely by Mantegna. He himself was greatly interested in antiquity, under the aspects of archaeology and literature, both of which he pursued and studied relentlessly.

In the painting, *The Death of the Virgin*, he showed his grasp of reality as being direct and immediate. The onlooker, as already with Masaccio's *Trinity* (page 1), is drawn into the space of the picture by the chequerboard of the marble floor. He can thus imagine himself standing beside the apostles. A vast hall creates a break between us and the main event of the panel. We can enter and dwell not far from the hard bench where the Virgin lies. Unseen and therefore not

likely to disturb the mourning apostles, we can stand back and share in the general grief: there is space for our grief too.

Lit by a harsh light, the edge of the bench and the Virgin's body emphasise the cold frozen state of death. Yet the well-defined verticals and horizontals which give the composition its classical balance, lend the picture a serenity that lifts us from the contemplation of death to admiration of the lake beyond. In the harsh reality of the foreground we can touch and feel for ourselves the apostles' hands and feet, their grimaces and darkened skins, the hard floor and pilasters against the wall. But as the picture moves into the soft atmospheric treatment of the landscape in the background we can see how the Renaissance styles of Italy and of northern Europe have finally come together. The luminous pool of water, the buildings and bridges bathed in light, the soft azure shadows are an application of northern aerial perspective (page 30), perfectly joined to the Florentine one-point perspective (page 37) of the foreground. Mantegna is one of the first artists to benefit from both traditions. This is perhaps because he must have seen in Padua both the Florentine art of Donatello and also that of Giotto – whose Arena chapel there was perhaps his greatest artistic work – as well as the numerous works of Flemish artists gathered together by Venetian and other northern Italian collectors.

GIOVANNI BELLINI AND THE VENETIAN RENAISSANCE

It is often said that the great difference between Florentine and Venetian art can be summed up in two words: 'drawing' and 'colour'. This means that the basis of a Florentine painting was the underlying drawing which the artist worked on until it was perfect, and to it added colour. The Venetians instead, it is argued, applied their colours directly to the panel or canvas, following at the most only a very rough sketch. But this is only true after about 1500. Until then drawing had been as important to Venetian artists as to the Florentines. The Bellini family demonstrated this well. The artist Jacopo Bellini had compiled a book of drawings which his sons, Giovanni and Gentile used while learning to paint. So did their brother-in-law, Andrea Mantegna. On Jacopo's death the book was

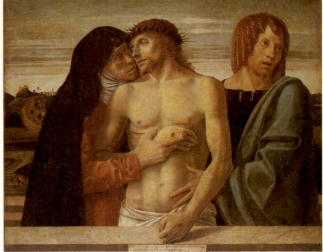

above
Giovanni Bellini, *The Mourning of Christ*, *c.* 1460, pen drawing, 13 × 18 cm, Louvre, Paris.

right
Giovanni Bellini, *Dead Christ with Virgin and St John*, *c.* 1460, wood panel, 86 × 107 cm, Brera, Milan.

opposite top
Giovanni Bellini, *Agony in the Garden*, wood panel, 81 × 127 cm, National Gallery, London.

opposite bottom
Andrea Mantegna, *Agony in the Garden*, wood panel, 53 × 80 cm, National Gallery, London.

left to his elder son Gentile who, on his death, left it to his brother Giovanni.

In Giovanni Bellini's drawing of the dead Christ, the artist showed his debt to his father; but he already showed also a great response to light. The light here is a vibrant current which swiftly passes over things, unable to penetrate some, flattening others. Different intensity of light picks out Mary's arm supporting Christ's neck and the angel's head, with his bleached hair, and bright back. Christ's right shoulder and arm, and his wounded breast strike the strongest note in this scale of blacks and whites.

A glance at the painting which is supposed to be based on the drawing shows how Giovanni Bellini could manipulate light, endowing the pink tints of the flesh with a hundred nuances. The infinite gradations of greys and greens, yellows and browns seem to reflect different reactions to the death of Christ.

Where did Giovanni Bellini, one of the most consistently great of Venetian artists, find inspiration for such a subtle gradation of colour? The earlier works of the Venetian school, bright as they may have been, were composed of strong contrasting but flat areas of colour. They showed a complete lack of understanding of the subtle hues to be found in nature.

Bellini is thought to have known works by the Flemish artists, van Eyck and van der Weyden which by this time were in collections in Venice and Ferrara. Yet his rich colour with the iridescent complexity of each tone is different from the more stable and even treatment of the Flemish. The answer lies elsewhere. Bellini must have

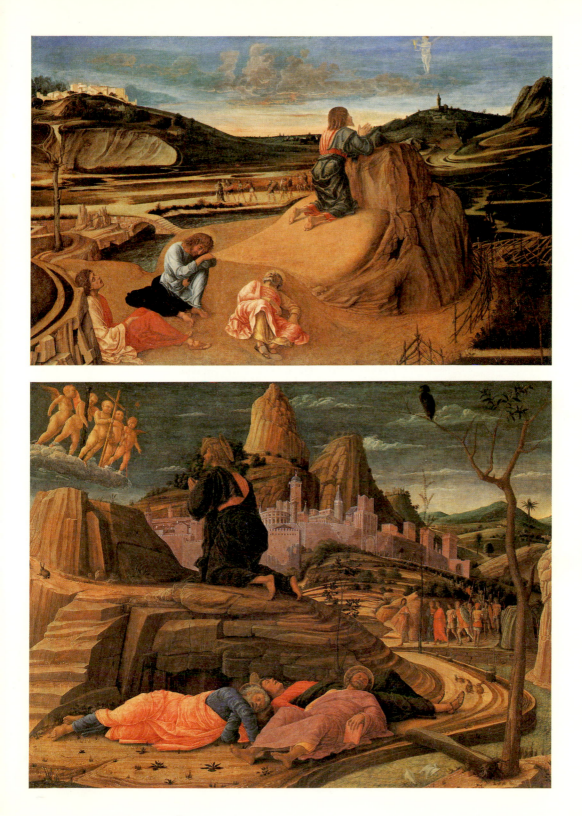

learnt for himself from a close observation of nature. We can see this if we compare two paintings of the same scene, *Agony in the Garden*, one by Giovanni Bellini and one by his brother-in-law Andrea Mantegna.

Mantegna's painting is dramatically made up of a series of incidents drawn together by the treatment of the landscape. Hard rocks and strong curving lines cut into the rock enclose and echo the outlines of the main characters. The strong foreshortening of the apostles' bodies seems to bring them into our space; Christ kneeling on the hard rock, seems to move back towards the contours which repeat his silhouette, the recognisable peaks of the Italian Dolomites; Judas leading the guards, dominates the middle ground where two main curves of the rocky path come together. His swerving cloak starts the next curve up the hill.

Bellini, in his *Agony in the Garden*, was influenced by Mantegna's incisive manner but his own vision of nature has begun to emerge. He cannot help but soften the slopes, widen the curves, slow down the pace. A series of horizontals in the middle distance steadies the composition, while the sleeping figures have less and less significance. The apostles asleep in the foreground seem absorbed into the landscape, almost merged with the ground, while alone, silhouetted against the sky, Jesus faces the sky in silent prayer. The light of an early dawn advances steadily, with the promise of another day. It is this communion between nature and man, united in the embrace of light, which gives Bellini's picture its unique religious sense.

Giovanni Bellini became one of the most complete Renaissance masters, well versed in the understanding and practice of Renaissance innovations and techniques. In this he was helped by the arrival of Antonello da Messina, the great oil painter from Sicily and a master of perspective and composition. But Bellini's unique contribution to the art of the Venetian Renaissance, and indeed of all the later Renaissance, was his sensitivity to colour under all its varying tonalities, and his amazing response to the colours contained in light and air. If we define tone as colour's response to light, we may come to understand the secret of Bellini's painting to be in that underlying sensitivity to tone which like a sustained chord of music pervades all his greatest compositions.

LEONARDO DA VINCI: A NEW APPROACH TO ART

Fifteenth-century Florentine artists had longed to combine the perfection of the Greeks with the grandeur of the Romans. To this combination they had added a realism of representation which would achieve 'the new art', not imitative but equally great. As we have seen they also identified their ideals with those of the Greeks. Florence was to stand for freedom, for sharing in government, and for self-respect. Man was to live up to an ideal of human perfection, matched and expressed in the idealistic shapes of Renaissance art and architecture. The artists of the early Renaissance followed a clear path lit by an unclouded sky. Brunelleschi's geometrical shapes have no hesitation, they are like a mathematical equation; the paintings of Angelico and Masaccio have no shadows; the statues of Donatello present a well-defined outline. But after 1480 these ideals were no longer valid. Leonardo's horizon starts clouded; his paintings will need the shadows and the darkness from which to rescue the fewer moments of light. Many of his drawings have a shaded ground from which the golden tones of young cheeks, the highlights of curly hair, the glow of a ray of sun emerge all the more startlingly. The need for wider experiences, and perhaps a dissatisfaction with Florentine art, and the realities of Florentine politics and society, led him in 1481 to ask Lorenzo the Magnificent for a letter of introduction to Ludovico il Moro, ruler of Milan.

In 1482 Leonardo arrived in Milan where he soon gained the admiration of the whole court for his skill, not only as painter, but as musician, engineer, choreographer, architect, town planner and adviser on all technical matters. He developed close links with the University of Pavia where he spent many days consulting books on science and philosophy, soon finding many answers in the empirical philosophy of Aristotle. Alchemy intrigued him as did the rational abstraction of mathematical symbols. But although an examination of all these spheres is beyond the scope of this introduction to Renaissance art, Leonardo's natural and scientific curiosity can be the clue to a greater understanding of his works of art. It also becomes a new and distinctive element of the High Renaissance, that final development of Renaissance art which took place after 1480.

Leonardo da Vinci, Angel, from Andrea del Verrocchio, *Baptism of Christ*, 1470–2, Uffizi, Florence.

7 The High Renaissance

'MOST ABUNDANT IN COPYING AND MOST PROFOUND IN ART'

'To the boldness and greatness of design Leonardo adds the counterfeiting of all the minute details of nature, just as they are . . . he is most abundant in copying from nature and most profound in artistic technique.' In this description of the artist's technique, Vasari caught, almost as a sudden intuition, the change in art from the fifteenth century to the sixteenth. Leonardo started from nature, as Renaissance art rules prescribed, but a nature now observed almost scientifically. From this observation art sprang freely, bending the rules inherited from the classical tradition whenever necessary. Perhaps by looking at Leonardo's practices when painting, practices frequently described by the artist in his own notebooks, we can infer something of this new and original approach to artistic rendering.

Very few artists drew as much and painted as little as Leonardo. No more than fifteen paintings and one fresco have survived, while his drawings of places and natural phenomena are very numerous indeed. Drawings of places we call them, to distinguish them from 'landscapes', of which he has left very few. The recording of places seems to have been Leonardo's principal aim. He recorded places as he recorded other natural phenomena in the way experience revealed them to him, sometimes brushed by a momentary light, at other times enveloped in shadow. Each element is revealed in the moment when it becomes apparent to the senses. Yet there is another aspect to Leonardo's paintings and drawings: their mystery and fantasy. Where does this come from? Some extracts from Leonardo's letters give a glimpse into the world of his own experiences. In more than one the artist referred to a journey in southern Italy where among other sights, he witnessed the fury of Mount Etna and the foaming waves between Scylla and Charybdis. In one he goes on to describe how: 'unable to resist my eager desire and

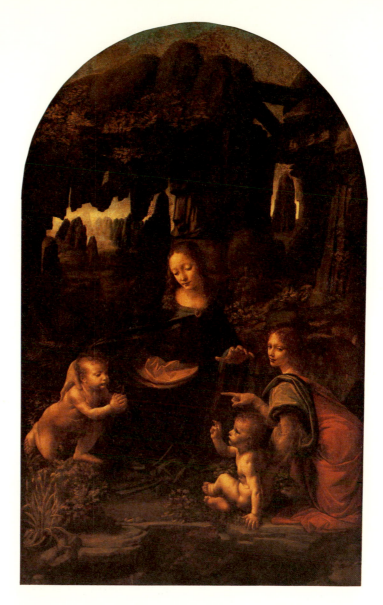

Leonardo da Vinci, *Virgin of the Rocks*, *c.* 1491–3, wood panel, 189.5 × 120 cm, Louvre, Paris.

wanting to see the great multitude of the various and strange shapes made by nature, and having wandered some distance among gloomy rocks, I came to the entrance of a great cavern. I stood in front of it for some time, astonished that such a thing could be. Bending my back I rested my tired hand over my downcast and contracted eyebrows; I bent first one way and then the other, to see whether I could discover anything inside but this was prevented by the deep darkness within. After I had remained there some time, two contrary emotions arose in me, fear and desire: fear of the threatening dark

Leonardo da Vinci, *Rocks with Aquatic Birds*, pen drawing, late 1470s, Royal Library, Windsor.

cavern, desire to see whether there were any marvellous things within.'

We do not know whether Leonardo's letters are real or imaginary. He wrote them in diary form and we do not even know whether any ever reached its destination. It is possible that Leonardo did travel southern Italy, perhaps around the years 1476–8 when we have no documents to account for his presence in Florence or anywhere else. This particular letter has been dated, from the handwriting, to about 1476.

Even if he saw, as he claims, these landscapes and grottoes, we must not forget that he used them as the basis for pictures only after his arrival in Milan. This means a gap of several years and one wonders whether the enchantment and mystery of the south came back to him more poignantly in the grey mists of Milan, surrounded by the flatness of the plains of the River Po.

If we look now at Leonardo's painting of the Virgin of the Rocks, especially the first version, now in the Louvre, dated 1491–3, the artist's description of 'the various and strange shapes of nature', 'the entrance of a great cavern' in front of which he stood astonished, 'the deep darkness within' and his desire to see whether there were any marvellous things, comes to one's mind. Beyond the faithful rendering of details (for some of which, plants and rocks, we have precise drawings) we sense that mystery which Leonardo found in nature and recorded over and over again in his notebooks, and which could explain the magic of his paintings.

When we look at any of his works, the *Virgin of the Rocks*, or the *St Anne* in the Louvre, or the *Mona Lisa*, or the fresco *The Last Supper* in Milan, we are caught in a spell. It is difficult to detach oneself enough to look at them as a whole. This is no fault of the composition which is always perfect and contained within geometric, often pyramidal, arrangements that gradually emphasise each element of the work. Observe how in the *Virgin of the Rocks*, the Virgin dominates the centre of the picture. Her position is strengthened by the main rocky mass which like a natural column emphasises the centre and the depth of the composition. The darkness of the rock's surface brings out, by contrast, the radiant glow of the Virgin. At her left the angel, and at her right the little St John, their features picked out by rays of light, widen the pyramid and enrich it with strong accents of colour. Each colour reverberates in the background into a thousand softer tonalities. The baby, bathed in divine light, his hand and profile raised in the act of blessing, is the actual pivot of the composition. Sitting at an angle to the rocky outcrop behind the Virgin, he steals from her the centre of the scene. His supporting left hand is the focus for a shaft of light which quivers over the delicate limbs, and leads towards his head, the angel's and Mary's hands. Every single element points to his special position in the scene. But if we let our eyes wander freely over the painted surface, detail after

detail claims our attention. Their exquisite rendering, their perfect pictorial technique make it almost impossible to steal away.

As Vasari has said, *art* – that new term which now stands for invention, skill and the artist's poetic licence – has added a new dimension to the acute scientific observation of nature. The combination of the two is High Renaissance art.

FROM PAINTING TO POETRY

When in the year 1500 Leonardo escaped from a Milan recently conquered by the French, and arrived in Venice, the enchantment of that city, the queen of the Adriatic, must have touched him deeply. He was lucky enough to find there many other expatriates from the court of Lodovico il Moro: Lorenzo da Pavia, the gentle-man musician and lute-maker who had built such famous instruments for Beatrice D'Este, wife of Lodovico, duchess of Milan and sister to the famous Isabella D'Este, marchioness of Mantua; Aldo Manuzio, the famous originator of the Aldine Press, the first printing press in the north of Italy, where the best editions of classical and modern literature were being printed in the new unadorned, clear roman characters; Pietro Bembo, the humanist poet and courtier, friend of the D'Este sisters and patron of Giorgione, and many others. Through them Leonardo must have been introduced to the Venetian artistic world, the painters, the scholars, and that group of young romantic poets, philosophers and musicians of noble origin so closely associated with the painter Giorgione.

The relationship between Leonardo and Giorgione is most interesting and deserves more thorough investigation than it has been given so far. In Vasari's *Lives*, in the introduction to the third part where the historian deals with the art of the High Renaissance, we read: 'There followed in Leonardo's footsteps, at a certain distance from him, Giorgio da Castelfranco who shaded his pictures and gave a tremendous motion to certain things . . .' Vasari refers here to Leonardo's famous 'sfumato technique', his shading of contours and backgrounds in opposition to areas of intense light. The emphatic play of light and shade creates a special atmosphere, half way between dream and reality, and endows his pictures with

Giorgione, *Tempest*,
c. 1505, oil on canvas,
82 × 73 cm, Accademia,
Venice.

spiritual and psychological overtones. Giorgione was the first artist
to grasp the possibilities of Leonardo's technique and assimilate it in
his paintings. Perhaps he understood the art of the Florentine artist
because of a certain spiritual affinity with him. Both artists were
renowned for their musical talent: Leonardo for the marvellous
sounds he produced on the lyre; Giorgione for his lute playing.
They were both sought after by scholars and aristocrats who
recognised in each an élite mind and a refined sensitivity. The two
men represent a new type of artist, much higher on the social scale, a
type whom we can perhaps call 'the gentleman artist'.

Renowned for inventiveness and originality more than for skill as
craftsmen, these artists' lives, culture, and intellect brought them to
the forefront of Renaissance society. Thus we shall see Titian
introduced by a friend as 'the first man in Christianity', and visited
and revered in his old age by every crowned head who visited

Venice. Another of them Michelangelo, was often addressed simply as 'Il Divino' – The Divine One.

To return to Giorgione and Vasari's description of his art: 'There followed in Leonardo's footsteps, at a certain distance from him, Giorgio da Castelfranco who shaded his pictures and gave a tremendous motion to certain things, as can be seen in Venice in the School of St Mark, where there is livid thundering weather and the picture trembles and stands out from the ground because of a certain obscurity of well-understood shadows.' It seems that Vasari is not referring to one of Giorgione's best-known pictures, *The Tempest*, but to a lost fresco for the School of St Mark. But perhaps because of a similarity of subject, Vasari's description perfectly conjures up *The Tempest* – Giorgione's masterpiece – with its livid thundering sky threatening the whole scene, indeed the whole earth. The subject of the painting is not certain; it may be that the characters are Adam and Eve, facing, after their expulsion from Paradise, the cost of their disobedience. The Bible refers to Eve who is to bring forth children in sorrow and Adam who is 'to till the ground from whence he was taken' (Gen. 3.16,23). If so we can understand better the strong sense of association we feel in front of the nakedness of the woman, unprotected under the lowering sky and exposed to the Divine wrath. If we follow this interpretation, Adam is represented as resting a while from tilling the soil. If we look carefully at the tool on which he is supporting his weight, we find that it is a hoe, its blade just pushed into the ground. On the other hand there seems to be a discrepancy in Adam's expression. This does not illustrate the state of a man under God's curse: 'cursed is the ground for thy sake; in sorrow shalt thou eat of it all the days of thy life' (Gen. 3.17). The young man's figure, at ease and hardly concealing an air of superiority as his eyes brush past mother and baby, seems almost a personification of the dominant Renaissance male. But is this wrong? If we turn again to the Bible, we see that immediately following 'in sorrow thou shalt bring forth children' (Gen. 3.16) is 'and thy desire shall be to thy husband and he shall rule over thee'.

Giorgione's figure could be the Renaissance man's interpretation of the sacred text. We can almost recognise in it a sixteenth-century young Venetian aristocrat, dreamlike and refined, for whom the earth, instead of being ground to be tilled, has become the source of

romantic inspiration, as well as shelter for those under his care.

The two characters, pushed as they are to the right and left of the painted surface, appear almost marginal to what is going on around them. The natural elements in this work look more like the real characters: the green of the angry sky spreading as it does all over the scene, almost darkening under one's eyes; the tremor communicated to the houses, the bridge and the ruins by the sudden intermittent crashes of God's cursing thunder; the whole scene shaken and, as after a shock, frozen into a grimace. The landscape, which in reality is a view of Castelfranco, Giorgione's home-town, has a Leonardo-like sense of mystery with the dark tones contributing powerfully to give it that supernatural quality which seems to hold everything under a spell. This is particularly obvious in the woman, who looks straight at us without seeing, as if caught in the stupor of her first awareness of the Fall.

Here Giorgione, with his artistic and poetic invention, has indeed created a great idyll, strong in its contrasts, melodious in the harmony of its colours. The perfect control of his brushstrokes has achieved all the polish of a poet's perfect rhyming. The shadows and doubts of Leonardo have been turned into the glowing incandescent hues of the first great Venetian High Renaissance painting.

COLOURS IN THE LAGOON

Whether it was a portrait of Ariosto, or a self-portrait, or just a portrait of a man, the 1510 portrait by Titian remains one of the most assured artistic statements that a young artist could make of himself, of the school and of the town to which he belonged. Titian painted it about 1510, when he was about twenty years old. He had already passed a brief apprenticeship with Giovanni Bellini and worked for a few years as assistant to Giorgione. This is one of the first great Venetian portraits, the beginning of a real school of portraiture which was to develop in Venice from Lorenzo Lotto to Tintoretto and Veronese. From these Rubens and Van Dyck would develop the type into the grand Baroque portrait of the seventeenth century, and spread the style through northern Europe to England.

With a pyramidal silhouette spreading at the base almost across

above
Titian, *Portrait of a Man*,
c. 1510, oil on canvas,
81.2 × 66.3 cm, National
Gallery, London.

right
Titian, *Assumption*,
1516–18, oil on panel,
690 × 360 cm, Santa Maria
de' Frari, Venice.

below
Lagoon, Venice.

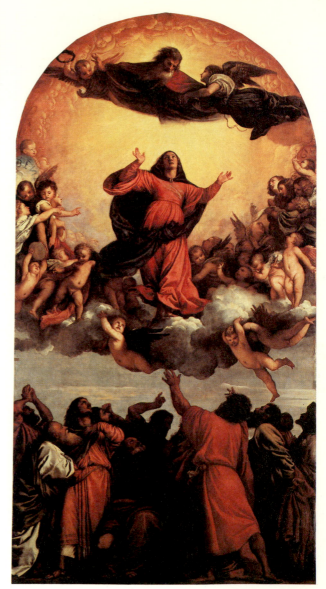

the whole canvas, the man with the blue sleeve is rendered with a
new freedom unknown to previous generations of Venetian paint-
ers. All the details show a bold approach. The classical pose is
underlined by the powerful horizontal of the window sill (carved
with Titian's initials, T.V.). The sleeve itself, spills over the ledge,
and is echoed in the blue expanse behind the man. The strong
contrast of light on the face and neckline opposes the black frame of
the hair and beard. A most definite artistic personality was already

Titian, *Self Portrait*, 1562,
oil on canvas, 96 × 75 cm,
Staatliche Museum,
Preussischer Kulturbesitz,
W. Berlin.

present in the twenty-year-old artist. But where his freedom of
approach and invention is most evident is on the dazzling virtuosity
of colour displayed on the sleeve. The sleeve is blue, shot with
whites, greys and purples, hints of pink and red and mauve. In this
range of colour tones, this chromatic display, we can see the whole
gamut of colour of the Venetian lagoon, that transparent mirror of
the inconstant but enchanting skies of Venice.

Titian was the first Venetian painter to look into the depths of
Venice's waterways, and capture the mystery and opulence of their
reflections. Venetian painting from this moment onwards became
that triumph of colour for which it is famous.

In his next work for the town itself, the painting of the Assumption for the church of Santa Maria de' Frari, Titian presented his definitive challenge to his fellow painters. In 1516 he offered his services almost for nothing in order to obtain the commission. On 20 March 1518 the completed *Assumption* was officially displayed on the main altar of the church. No structural framework holds the composition together as it always had done in fifteenth-century altarpieces, yet this composition is as clear and as structured as if it had included architectural features.

The apostles, in a variety of poses, kneeling, sitting, standing, or following with their extended arms the ascension of Christ's mother, create a firm rectangular base linking the composition with the beholder who finds himself at eye level with their bodies. A half moon of clouds slanting away from the foreground into the depth of the picture gives extended space to the pool of gold which glows behind Mary like a halo. Cherubs in all poses and foreshortenings, playing, flying, in ecstatic rapture, look towards the Virgin, while with the impetus of their own motion, they push high and away the ring of clouds that support her.

The Virgin, her red tunic swirling with the upward motion of her ascent, her blue cloak knotted and filled by the ascending winds, conveys the idea of levitation to the bystander. This is increased by the ascending spiral arrangement of the composition. The figure of God, foreshortened to the point of being only a head, and framed by a host of cherubs painted in differing intensities of golden light and golden shadow, brings the composition to a final point. It is a composition which, within its own progress, has reached from the human to the divine. Freedom and classicism, religious fervour and poetic licence, and above all light and colour unite in such a work to convey an enthusiasm and power rare in the history of painting. Look again at the apostle in white and green, and see how many colours make up the white of that fabric. Only the lagoon, whitening under a sky announcing storm and lightning to come, can give us a clue to such a range of colour.

From the 1520s Titian was to become the most renowned painter in Europe. He was employed by the lords of Italy, by popes and emperors. Charles V made him Count Palatine and endowed him with a yearly income, which his son Philip II increased. He

continued to paint pictures of marvellous variety. The most regal portraits endowed with all the dignity and reserve of power, or the freest mythological interpretations, or the most sensuous female images, or solemn religious compositions, every kind of image in the art of painting found in Titian its most advanced and complete Renaissance expression. And that very freedom of pictorial technique which we detected in the early *Portrait of a Man*, was to assert itself again in his last years as his greatest expressive gift.

In his self-portrait of 1562, now in Berlin and identified with the one Vasari saw in Titian's house when he visited him in 1566, Titian aged about seventy-two looks across the table, perhaps with failing eyesight, towards that same nature which taught him so much during his youth. His blues have now turned to burning reds and oranges, more suited to the winter seasons. The old man still presents an ample silhouette stretched right across the canvas and set back, for greater space, behind a table. The intensity of his eyes, the burning red of his lips picked up by the coral red of the chain around his neck, still reveal the skilled colourist. The flesh of hands and face is not painted in natural colours but rather to tone with the overall orangey glow of the sleeves, shirt and background. The brushstrokes, bold and unsmoothed, can be picked out one by one. The bold shadows at the side of the face, grey-green and black, are hardly strong enough to tone down the fiery red of the complexion. Splashes of pure white paint, which one of Titian's last pupils reported as applied thickly with the palette knife and then flattened with the thumb, add a brilliant touch to the otherwise sombre composition.

Whenever we speak of the Venetians as the great colourists of Italian painting, it is of Titian's last paintings, paintings like this one, almost monochrome in spite of the variety of tones, that we think. The warmth of those burning hues, lit by an internal hidden glow, which could be seen even with failing eyesight, communicates straight to the heart.

8 Perfection attained

The *Fight of the Centaurs and Lapiths*, a marble relief sculpted by a young Florentine in 1492 just before the death of Lorenzo the Magnificent, announced, powerfully and dramatically, a new genius. This was Michelangelo Buonarroti.

He carved the statue at the age of seventeen, probably when he was working in the garden of San Marco. Vasari described the garden as an open studio or 'academy' where part of the Medici collection of antique statues and reliefs was put at the disposal of young artists. There they could practise the art of sculpture under the supervision of Bertoldo, the old pupil of Donatello. Michelangelo's *Fight* has been described as classical, and as inspired by the sculptures of the Pisanos, Donatello, and Bertoldo; it also owes something to Pollaiuolo. Above all it looks experimental. The young artist was still trying to find out how to express his own inner vitality.

Whatever the marble represents (Herod fighting the centaurs, or the rape of Dejanira and the centaurs' fight, or Theseus fighting the centaurs), it shows us the struggle of a young genius in his first attempts to curb the hard and unyielding stone and to express an overpowering artistic message. This work, even if we now call it 'an attempt', is most assured. The polished, sweating, shining nudes of the foreground give way to the less finished surface of the more distant figures. An illusionistic atmospheric effect stresses the depth of the carving and holds the composition together. The central theme, a pyramid like those in Leonardo's pictures, is dominated at the top by the man with the raised arm, Herod or Theseus. It ends on the right and left with the two figures resting on the base of the marble, and is reinforced by being inserted in the overall rectangle of fighting bodies. This places the sculpture in the traditional category of Greek temple friezes like the Parthenon or Pergamon sculptures. But in Michelangelo's group there is a stronger impact.

Michelangelo Buonarroti, *Fight of the Centaurs and Lapiths*, 1492, marble relief, 84.5 × 90.5 cm, Casa Buonarroti, Florence.

This outburst of violent physical strain and passion is evident not so much in the individual treatment of the figures as in the linking of one figure with the next. It is above all evident in the artist's personal involvement, in his action and reaction to the inert, stubborn stone before him. From the very beginning his artistic struggle was to penetrate and defeat matter.

As an infant Michelangelo had been entrusted to a wet-nurse, the daughter and mother of stone-cutters. He himself later said that this event determined his future as an artist. Certainly it gave him a great familiarity with the stone which from childhood he was to separate, cut and shape. He learnt about its secret veins and natural joints, its hidden colour, more vivid after a summer shower or baked in long exposure under the hot sun.

Such was his knowledge and mastery over the stone, such was his involvement with the block of marble from which the statue would emerge, that he often made the journey to the quarries of Carrara, the best marble quarries of Italy, to select for himself marble from the mountainside. On one occasion, when choosing the material for Pope Julius II's tomb, he remained eight months, from May to December 1505, to select the forty marble blocks necessary for the project. We can only imagine what Michelangelo felt, high up on the mountains in those glorious summer months at the beginning of his artistic career.

In the mountains he could face nature where it comes close to the divine, and see it reflected in his own beloved and hated marble. He even thought of carving a colossus or some huge figure in the mountain itself, leaving it there to dominate the heights, or, to put it

Michelangelo Buonarroti,
St Matthew, *c.* 1505–6,
marble, height 216 cm,
Accademia, Florence.

Michelangelo Buonarroti,
*Sea God still embedded in
the Marble*, drawing,
1520–5, British Museum.

another way, leaving it to struggle with the matter from which it could not liberate itself. Michelangelo's extraordinary response to the stone made him often see the statue as already contained in it. As he said himself: 'I only take away the surplus, the statue is already there.' Even so, the struggle to free what he saw in the marble proved painful and exhausting. Matter (the stone) and form (the creation he would release from it) were like two powerful enemies struggling; or like a mother and child – the mother resisting separation, the child struggling for its own independence.

This contradictory attitude was to become the dilemma of Michelangelo's artistic career and is most evident in some of his unfinished works. *St Matthew* was a work started and abandoned twice between 1505 and 1506 because of circumstances outside the artist's control. It was to be one of twelve statues of apostles commissioned from the artist for the nave of the cathedral of Florence, but the only one ever started. The pope's imperious command to work on his funeral monument in Rome interrupted the work. As we now stand in front of the marble, the figure emerges as if life has come at last to one who had been embedded in the stone from time immemorial. Different viewpoints correspond to different degrees of finish. St Matthew seems sometimes clearly and powerfully defined, at other times absorbed into the stone. The block is both cradle and prison to the artist's work as well as to his invention which is now nurtured, now dwarfed by it. Technically the *St Matthew*, as Michelangelo left it, is particularly interesting, since it allows us to see his method of work. He started from the front of the marble block, and, as if carving a frieze, uncovered the figure as he proceeded into its depth.

The four slaves for the tomb of Julius II, left unfinished on Michelangelo's death, are another example of the artist's struggle to win a shape from the stone. The skill of the composition is all in the superb suggestion of emerging life, of figures freeing themselves from that matter that still holds them and from which they rebel.

Michelangelo, before the end of his life, was to accomplish that final stage, essential to the development of modern art, of distinguishing between an idea and its translation into a generally recognisable form. The artist, and his public with him, must have realised that in these rough unfinished surfaces his invention was

often more than adequately expressed. The internal conflicts and passions could find greater expression in the unsaid, than in what was plainly spoken.

THE ELOQUENT SILENCE OF THE LAST PIETÀ

The Madonna and child groups are another constant theme of Michelangelo's art. He composed five mother and son groups before starting the Sistine ceiling in 1508. These were the two marble roundels called the Pitti and Taddei *tondi*, the painted *Doni Tondo*, the first St Peter's *Pietà* and the *Bruges Madonna* of 1501. Later he made two more groups, one for the new sacristy of the church of San Lorenzo in Florence (between 1521 and 1534) and the other, called the *Rondanini Pietà*, which remained unfinished on his death. These two groups are his most intense, indeed almost desperate, statements of the mother and son theme.

In the San Lorenzo *Madonna* Michelangelo intensifies, in a spiral composition the frontal, restrained grief of the *Bruges Madonna* and the child's silent acceptance of the destiny he was to face. The baby's refusal to be separated from the mother is almost touching especially if we want to see it as an unconscious yearning for the mother on the part of an artist who lost his own mother at the age of six. A whole new development of style can be traced here. The *Bruges Madonna* with its classical frontal pose and vertical emphasis of the drapery was made in 1501 at a time when maximum artistic perfection was reached by Raphael, Leonardo, Perugino and Michelangelo himself.

The San Lorenzo *Madonna* belongs to a different artistic style, now known as Mannerism, a style inspired and started by Michelangelo though mainly expressed in the art of his follower Giambologna. In this style, the ideal composition for a figure or group, as described by Michelangelo in a letter to a pupil, should be the *figura serpentinata*: all the movements of the body should be represented in such a way that the figure has something serpent-like such as it has in nature, and as it had among the ancients and the best moderns. Michelangelo's spiral, intertwining group ends, as he said himself, in a self-consuming flame. Feminine, sweet, her profile

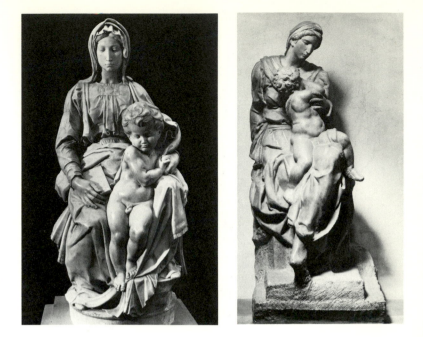

imperceptibly merging with the atmosphere, this Madonna has the softness but also the intensity of a flame, burning from within with the awareness of her son's future.

To one last marble composition, however, Michelangelo entrusted his most dramatic message. The *Rondanini Pietà* was a marble which he kept in his studio and continued to work on until the eve of his death. He started one version in 1552–3. This was abandoned and taken up in a second version between 1554 and 1564 as can be detected from parts of the marble finished but left disconnected, such as the arm of Christ, or the head started twice at different angles. Finally the group was reduced to absolute essentials. Mother and son are linked in a new revolutionary pietà composition, which interprets the theme psychologically rather than realistically. Is the son, the very reason for her existence, now supporting the mother even after his death, or is the aged and suffering mother holding the son upright in a last desperate effort to keep him alive?

What is clear now is that Michelangelo has reasserted at the end of his life the inseparability of mother and child, of the artist and his creation. The marble group has abandoned all classical restraint, but it finds an even greater restraint in its reduction to essentials. It refuses to express any anguish but is thereby more anguished. The marble itself is Michelangelo's language as he hacks it, now roughly, now smoothly, humping at the top, hollowing at the base.

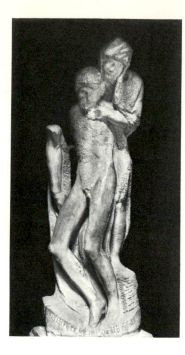

Michelangelo Buonarroti, *Rondanini Pietà*, 1554–64, marble, height 198 cm, Museo del Castello Sforzesco, Milan.

Michelangelo at eighty-nine was still carrying on the ancient struggle between spirit and matter, between invention and finished expression. Working during his very last days on this most unfinished of all his sculptures, he must have known who was the victor.

RAPHAEL'S MARRIAGE TO A NEW AND PERFECT HARMONY

If, as Vasari put it, the Renaissance is to be considered a point of arrival after a long climb towards perfection, in which the Gothic, Early Renaissance and High Renaissance are three successive stages, then Michelangelo alone reached the very summit. But it was Raphael (Raffaelo Sanzio) who, without the effort and the anguish of the last climb, set up a long-lasting basis for art by bringing Renaissance forms to their most classical, serene, and complete expression. He did this by his sense of form, by a new and perfect rendering of traditional themes, by almost unalterable solutions to the illustration of each story.

Looking at two panels of *The Betrothal of the Virgin*, the one by Perugino, painted around 1500–4, and the other by his pupil Raphael in 1504, we might at first think of a school exercise where the pupil copies his master to learn composition and painting

techniques. Yet if we look more closely we may think that there has been a mistake. Raphael has forgotten some figures from the foreground group – they certainly seem fewer; he has mistaken the distance between foreground and background; he has painted a smaller temple, forgotten to cut its top with the frame of the picture. Although it is smaller in the area it occupies on the panel, the temple gives the impression of being much larger. It is set further away from the figures whose size, compared to it, now make much more sense. It is set on a higher ground, with many more steps. Its round colonnade with the repetition of arches gives a circular movement to the composition which is echoed by the foreground group arranged as a semicircle slanting upwards. If we now count the figures on either side of the High Priest, we find that they are exactly the same as in Perugino's *Betrothal*; they only seem less crowded because of the more harmonious arrangement. Still following his master in facial expression and type, Raphael has far outdone him with his magnificent sense of composition. Look at the elegant pose with which Joseph and Mary are brought together, their arms stretching before the hands touch, but leaving enough space for the priest not to be squeezed behind their bodies. Joseph advances eagerly, Mary more timidly. It is enough to look at Mary's gently curved head and neck, the veil from her hair just caressing the sinuous line of her neck and shoulders, her whole two-third view reinforced and echoed by the green cloak which envelopes her like an embrace, to realise that the achievements of composition in pictures like Botticelli's *Judith* (page 61) had not been in vain. In the *Betrothal of the Virgin*, Raphael's treatment of the subject is exquisite and timeless.

THE TEMPLE OF THE HIGH RENAISSANCE

Raphael had brought together in his own interpretations the suavity of Perugino, the sense of space and proportions of Piero della Francesca and the sophisticated compositions of Botticelli. He had learnt in Florence the lesson of Leonardo and the art of Michelangelo; now he proceeded, with an awareness of history, to create an even more grandiose, more eloquent, more classical style to meet a new historical situation.

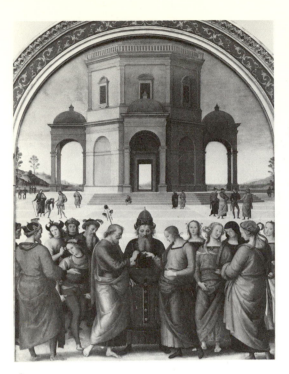

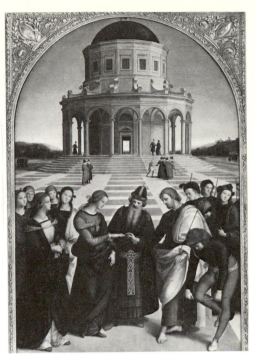

Following in the footsteps of Bramante, the architect from Urbino who settled in Rome in 1500, and Michelangelo who since 1508 had been painting the ceiling in the papal chapel, Raphael arrived in Rome in 1508; he arrived at the moment when the city was beginning to embody Pope Julius II's dream of reviving the glory and grandeur which had distinguished it in the past. Rome was destined to become the capital of a new Christian Roman empire forged by the pope's military skill. Julius was fully aware of being more a military than a religious leader. When Michelangelo who was making a bronze statue of Julius asked whether he wanted a book or a Bible in his hand the pope said 'Put a sword there, for I am no man of literature.' But his dream was not only political; it was to restore the dignity which had been stripped from the papacy by the scandals of the Borgia's pontificate. It was a dream not only of power, but of a return to old ideals and old history, a programme with which artists could identify, which could fire the great ones, and encourage the mediocre.

In 1502 Bramante had built a temple in the courtyard of the church of St Peter in Montorio, on the spot where St Peter was thought to have been crucified. It was a building with historical significance belonging to the Christian legend for its function, and

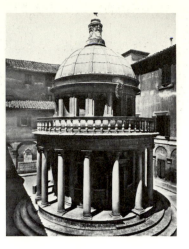

Donato Bramante, Tempietto, 1502, San Pietro in Montorio, Rome.

to the Roman inheritance for its style. Even though the dimensions are minute the temple is a perfect model of Roman style. The column is its module, its basic unit of measurement to which every other element is related. It dictates the circumference of the three concentric rings of the outer steps, of the colonnade with the bright balustrade above, and of the dome's drum. It dictates the size of the windows, doors and niches. You need only alter the size of the columns, and then everything else in relation to produce a temple of any given size and impressiveness. Julius II, looking at Bramante's temple, must have understood its implications and realised the importance of an artist like Bramante for his programme of restoring the greatness of Rome.

Whether Raphael and Perugino knew Bramante's temple when they painted the betrothal panels is not known; they certainly knew, as did Bramante, Piero della Francesca's panel of *An Ideal Town*. This picture was evidence of an earlier Renaissance concern with new urban spaces modelled on a series of proportional and superbly harmonious relations. Yet Piero lacked that sense of volume, the strong contrast between the empty and the full, in other words that massiveness, which Bramante rediscovered for Julius's Rome. It was Bramante's sense of Romanitá, or sympathy with ancient Rome, which led Julius to entrust to him the rebuilding of the main church of Christianity, the five-aisled basilica of St Peter.

In Raphael's fresco of *The School of Athens* we see the basilica as Bramante must have conceived it, in plans that Raphael certainly knew. It was a basilica made up of huge halls rather than naves, with its white marble and luminous dome and archways open to the sky. Raphael's frescoes and Bramante's Roman projects celebrated the

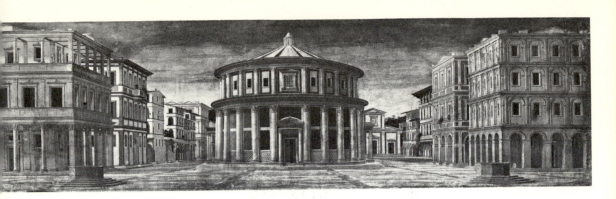

Piero della Francesca,
*Perspective of an Ideal
Town, c.* 1470, panel,
60 × 200 cm, Ducal Palace,
Urbino.

Raphael, *School of Athens,*
1509–11, fresco, 670 cm
wide, Stanza della
Segnatura, Vatican, Rome.

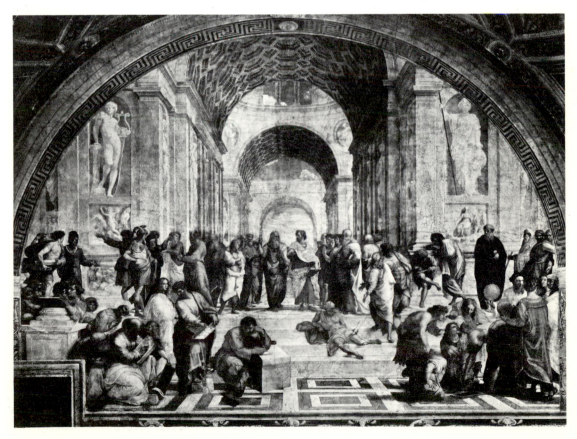

greatest moment of certitude in the High Renaissance. It was a style, a mode, a way of thinking; looked at from within the painted walls of the Vatican it must have seemed that it would last forever.

MICHELANGELO'S 'LAST JUDGEMENT': AN END AND A BEGINNING

In 1523 Clement VII, a Medici pope, succeeded the great Renaissance patrons Popes Julius II and Leo X. It was a time when European nations were asserting their independence and questioning their obedience to the Church of Rome. Individuals too were making new claims in matters of religion – Martin Luther was only one example. The new pope tried to play off one monarch against another by making a series of alliances only to break them when his purpose was served. It was a vain attempt to continue his predecessor's policy of expanding the papal territories and it ended in disaster.

In 1527 Charles V of Spain's unpaid and desperate mercenary troops sacked Rome and wrought destruction for three days. They desecrated churches and emptied palaces of their treasures. People and clergy were at the mercy of the troops. The pope's Vatican palace was occupied.

The sack proved even more devastating to the culture of Renaissance Rome than to the dignity of the pope. It came to represent what men and politics could achieve, to embody all the wrongs and instability already present in Renaissance society, in believers and non-believers alike, in pagan humanists and depraved Christian leaders, in selfish and limited human aims. The Renaissance beliefs, nurtured all through the fifteenth century, in man's ability to manage his own affairs, the hopes for a more ethical and aesthetic, nobler and fairer society, all were abandoned on a heap of rubble.

The pope, however, partly redeemed himself as regards art with his final act of patronage. He summoned Michelangelo back from Florence to Rome, and commissioned a fresco of the Last Judgement for the Sistine chapel.

On 31 October 1541 Michelangelo's great fresco was uncovered

above the altar of the Sistine chapel, 'to the astonishment and wonder of the whole of Rome, in fact of the whole world; and I who went, in that very year, from Venice to Rome, in order to see it, was astounded'. Thus Vasari reported his own and his contemporaries' views of Michelangelo's work. This time an eye-witness as well as pupil, admirer and friend of the great artist, his testimony is particularly important as to the reaction at the time to such a key work in the history of the Renaissance.

It was the last in a series of pictorial decorations begun seventy years before to adorn the pope's private chapel in the Vatican. It put the seal on the long movement towards the perfection of Renaissance painting which only Michelangelo was to reach. Ironically in reaching it, he also overtook it, leaving behind the Renaissance rules and criteria for art.

In the Sistine chapel biblical scenes had been frescoed in the 1470s by Perugino, Botticelli, Rosselli and other Florentine artists recommended to the pope by Lorenzo the Magnificent. Next, Michelangelo had painted his own scenes of the creation along the ceiling of the long chapel. In a rhythmic progression of space and time, the creation of the earth, man and the elements unfolds, each act isolated and contained within the powerful grid of Michelangelo's painted architectural framework. Now, last of all the Judgement, unframed and devoid of any progression of time or logic, spreads over the whole wall behind the altar.

In it a more than life-size humanity presses, pushes and demands to be chosen. Here are people still guided by human reasoning, and still looking for the fulfilment of their expectations. Bearing the symbols of their martyrdom or good works, they press around the most colossal Christ ever painted. Before this figure, the pivot and focus of the whole work, they ask for vengeance. But their answer is summed up by one gesture, that definitive, imperious raising of the hand, with which Christ seems to put an end to all turmoil, to revenge and passion, rebellion and conflict.

This gesture which echoes with different intensity all over the composition, and is expanded in the sound of the trumpeting angels, is the unifying force of the whole work.

The souls naked in front of God – those famous nudes so admired by Vasari as the greatest Renaissance expression of human anatomy,

and so despised by later prudes who had them covered – are caught in a cosmic rhythm, a circling movement which the artist gives to the composition, starting upward on Christ's right and concluding downwards on his left.

The single episodes of the work, magnificent as they are in their individual treatment, are submerged in the overall rhythm. Above all human passions and fears, above evil and good, Michelangelo presents this inscrutable God with his own justice, his own divine rules, not to be understood by the human mind.

With the formal treatment of this work, Michelangelo has over-come the Renaissance preoccupation with human dimensions and space, with natural proportions and artificial perspective. In this final pictorial statement the artist has overcome the concerns of more than a century for man and his environment, nature and the self. The *Judgement* is a hymn to God and to a divine dimension. Not linear but cosmic perspectives are to be understood in the blue glimpses of infinity; not colours reflecting sunlit or clouded views of towns or countryside, but the dark tones of despair and the bright-ness of redemption are hinted at in the thundering hues of the *Judge-ment* with its strange radiant whites and blues.

The central zone is the brightest, where Christ appears in isolation almost in spite of his mother, who is perhaps too human to understand his laws. The lowest zone is the darkest. There on Christ's right are the uncovered tombs and the dead rising to meet their judgement; on his left those finally rejected are led for ever into darkness.

In front of the *Judgement* we feel that Renaissance individualism is at an end. Not only individuals are being judged here, but humanity itself and a very confused humanity at that. The good are hardly distiguishable from the bad, the right from the wrong. The upward movement of those on Christ's right is hardly more uplift-ing than the downward movement of those discarded on his left. Anguish is on everybody's features, an anguish only momentarily relieved by hope. The intensity of the emotions held and released like clashing waves of sound communicates to the beholder with unprecedented vigour. Restraint is no longer the characteristic of this artistic message. The *Judgement* is a long sustained cry for the waning of the human ideal. And yet one detects in it also another

opposite
Michelangelo Buonarroti, *Last Judgement*, 1536–41, fresco, altar wall of the Sistine chapel, Vatican, Rome.

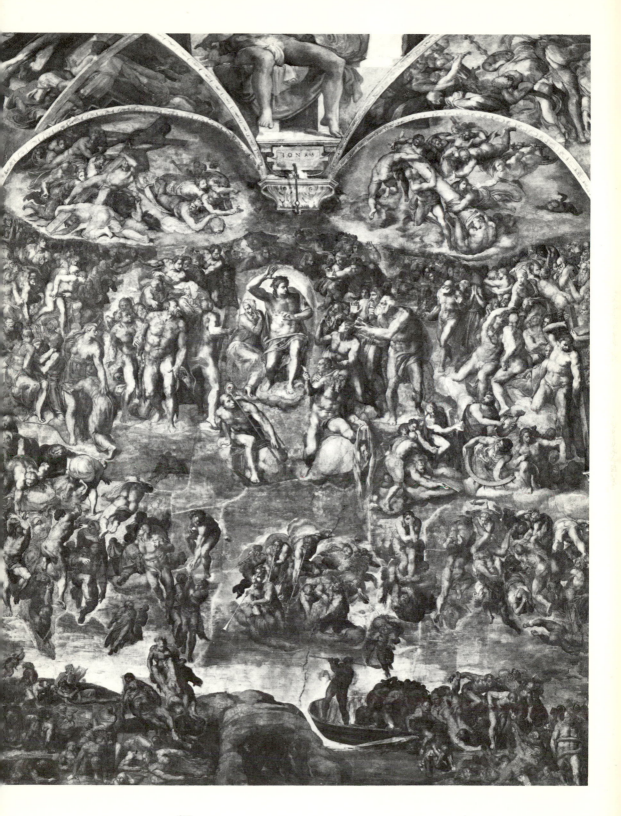

97

note, a note of humility, a deeply felt need for comfort and help, an intense cry to believe again, if not in man, then in God.

Humbled in front of his creator, Michelangelo, with God's help, is heralding here a new artistic conception. With this work he announces the art of the next century. That art, now called Baroque, will be the art of the masses, the art which wants to solace and console. A new generation of men will look for a new relation with God, more intense, more emotional, more imaginative.

If the Renaissance had done nothing more than reveal man to himself and from that revelation lead him, even if disappointed, to a deeper faith and a more intense relationship with himself, God and nature, it would have been a magnificent achievement.

Notes on artists

BELLINI, GIOVANNI, born Venice 1430, one of an important family of artists; remained in the family workshop until *c*. 1459, much influenced by his brother-in-law Mantegna; worked mainly on religious themes, particularly Madonnas, one of his major works being *The Agony in the Garden* 1465; employed in the Doge's palace from 1479, becoming chief state painter. Died 1516.

BOTTICELLI, SANDRO, born Florence *c*. 1445, probably studied under Filippo Lippi and worked mainly on religious and mythological themes: *The Birth of Venus* is one of his best-known works. He may have come under the influence of Savonarola who led a crusade against the 'abuses' of Renaissance Florence which included painting. After a period of prosperity, 1480–1500, his popularity greatly declined. Died 1510.

BRAMANTE, DONATO, born near Urbino 1444, went to Milan *c*. 1482 where he began his career as an architect and moved to Rome 1499. Much interested in perspective and classical architecture; from *c*. 1503 to his death he worked on the design for rebuilding St Peter's in Rome. Died 1514.

BRUNELLESCHI, FILIPPO, born Florence 1377 and executed all his major architectural works there. Principally interested in constructional techniques, he developed new ways of erecting a dome. The dome of Florence cathedral was his major feat. Died 1446.

DONATELLO, DONATO DI NICCOLO, born Florence 1386 and apprenticed as a sculptor to Ghiberti; working on the Baptistery doors 1403 and in Florence cathedral from 1406; produced works in partnership with the sculptor Michelozzo from *c*. 1425; visited Rome 1401–3, Padua 1443–53. The most influential individual artist of the fifteenth century, he revolutionised sculpture, moving in his own work from the purest classical style to the very powerful dramatic sculptures of his later years. The bronze *David* is an illustration of his classical period and the wood *Mary Magdalene* the masterpiece of his later work. Died 1466.

EYCK, JAN VAN, born Maastricht *c*. 1390; entered the service of Count John of Holland 1422; appointed court painter to Philip the Good, duke of Burgundy 1425 and travelled on secret diplomatic embassies to Spain and Portugal for him 1426–36; worked in Bruges from 1430 to his death. The greatest artist of the early Flemish school, an innovator in the technique of oil painting, one of his most famous paintings is *Giovanni Arnolfini and his Bride* 1434. Died 1441.

GHIBERTI, LORENZO, born Florence 1378 and trained as a goldsmith; won competition to make pair of bronze doors for the Baptistery in Florence 1402; devoted rest of his life to making these and a second pair, said by Michelangelo to be worthy to be the Gates of Paradise: formed

workshop which trained whole generation of Florentine artists. Died 1455.

GIORGIONE, born Venice *c.* 1476, pupil of Bellini; worked in Doge's palace 1507; worked with Titian to fresco the Fondaco dei Tedeschi 1508; first exponent in Venice of small oils for private collectors rather than large works for church and state patrons. Died, probably of plague, 1510.

GIOTTO DI BONDONE, born Florence *c.* 1266, probably a pupil of Cimabue; joined painters' guild 1311; was court painter to Robert of Anjou 1329–33 and overseer of work on Florence cathedral 1334; worked for Visconti in Milan 1335–6. Particularly noted for his frescoes and the humanity of his figures, the *Life of St Francis* in Assisi (though disputed) 1297–1305 and the *Lives of the Virgin and Christ* completed *c.* 1303 in the Arena chapel, Padua, are among his most famous works. Died 1377.

LEONARDO DA VINCI, born Vinci 1452, trained as a painter under Verrocchio and entered painters' guild 1472; went to Milan 1482, working for Lodovico Sforza, where he painted the *Last Supper* 1497 and *The Virgin and Child with St Anne and St John*; returned to Florence 1500 when the French invaded Milan; worked for Cesare Borgia as a military engineer 1502–3; in Florence painted fresco of *Battle of Anghiari* 1504–5, *Mona Lisa c.* 1503; returned to Milan in 1506 and was made painter and engineer to Francis I of France 1507; went to Rome 1513–16 to seek, though unsuccessfully, the pope's favour and left Italy for France 1517. Leonardo was universally gifted as inventor, scientist, architect, musician, mathematician as well as being a painter and superb draughtsman. Died 1519.

MANTEGNA, ANDREA, born near Piazzola, northern Italy, *c.* 1431; pupil of Squarcione; worked first in Padua, then in Mantua where he became court painter to the Gonzaga family 1460; painted frescoes in their palace illustrating the lives of the family, the most important in the *Camera degli Sposi* completed 1474. Died 1506.

MASACCIO, TOMMASO DI GIOVANNI, born Florence 1401, entered painters' guild 1422; worked on his greatest paintings, the fresco of the *Trinity* in Santa Maria Novella, Florence, and those in the Brancacci chapel, Florence between 1425 and his death in 1428 when only twenty-seven.

MICHELANGELO BUONARROTI, born Caprese 1475 moving almost immediately to Florence; apprenticed to Ghirlandaio 1488 then transferred to the Medici school run by Bertoldo under the patronage of Lorenzo the Magnificent; went to Bologna in 1494 and to Rome in 1496 where he carved his *Pietà* in St Peter's; he was in Florence in 1501–5 where he carved his *David*, summoned to Rome in 1505 to build a tomb for Pope Julius II but left after a quarrel; was again in Rome in 1508 working on the ceiling of the Sistine chapel; he was in Florence from 1524–34 to work on the Medici chapel but then settled finally in Rome where he remained until his death; between 1536 and 1541 he painted the *Last Judgement* in the Sistine chapel but then became increasingly active as an architect, particularly as chief architect of St Peter's; before his death in 1564 at the age of eighty-nine he

carved three more *Pietàs*. Known as the 'divine Michelangelo' he was recognised as a genius in his own lifetime, a great poet and architect as well as painter, sculptor and draughtsman.

PIERO DELLA FRANCESCA, born Borgo San Sepolcro in Umbria *c.* 1410; studied in Florence and worked independently in Borgo, Rimini, Ferrara, Arezzo, Rome and Urbino; town councillor in Borgo 1442; stopped painting in the 1470s perhaps to concentrate on mathematics. One of his most famous works is the fresco depicting the story of the Cross which he began in Arezzo 1452. Died 1492.

RAPHAEL (RAFFAELO SANZIO), born Urbino 1483, the son of a painter; studied under Perugino and then went to Florence where he absorbed the teachings of Leonardo and Michelangelo; summoned to Rome by Pope Julius II 1508 to work on the decoration of the papal apartments in the Vatican which are his greatest achievement; while in Rome he painted the altarpieces the *Sistine Madonna* 1512 and the *Transfiguration* 1520, succeeded Bramante as architect of St Peter's 1514 and became superintendent of the streets of Rome, responsible for all town planning 1517. Died 1520.

TITIAN (TIZIANO VECELLIO), born 1487 in the Dolomites and trained by the Bellini and then by Giorgione; was in Padua in 1510 working on the frescoes in the Scuola del Santo, before returning to Venice in 1512 and becoming painter to the Republic in 1516 in succession to Bellini; completed his *Assumption* for the Frari Church, Venice 1518; met Emperor Charles V in Bologna 1532 and painted his portrait; subsequently created count palatinate, court painter and became a personal friend of the emperor; visited Rome 1545–6 for the only time in his life and there painted the cruelly revealing *Pope Paul III and his nephews*; visited the imperial court in Augsburg 1548–9 and 1550–1, engaged in painting semi-official portraits of court personages; worked for Charles V's successor Philip II of Spain. A painter of religious, mythological, historical subjects as well as of most of the famous men of his time, superb in his handling of colour, Titian dominated Venetian art during its finest period. Died 1576.

VERROCCHIO, ANDREA DEL, born 1435 in Florence, perhaps a pupil of Donatello; worked chiefly as a sculptor for the Medici; Botticelli, Leonardo da Vinci and Perugino were pupils in his prosperous workshop. Died 1488.

WITZ, CONRAD (KONRAD), born *c.* 1400 in Swabia but settled in Basle where he joined the Basle painters' guild 1434. An extreme realist his most famous painting *Christ Walking on the Water* 1444 recognisably portrays part of the Lake of Geneva. Died 1444.

Further reading

Baxandall, M. *Painting and Experience in Fifteenth Century Italy*, OUP, 1972

Bruckner, G. A. *Renaissance Florence*, Wiley, 1969

Burckhardt, J. *The Civilization of the Renaissance*, The New American Library, 1960

Clark, K. *Civilization*, BBC and J. Murray, 1969

Gombrich, E. H. *Norm & Form*, Studies in the Art of the Renaissance, Phaidon, 1978

Gombrich, E. H. *The Story of Art*, Phaidon, 1978

Gombrich, E. H. *Symbolic Images*, Studies in the Art of the Renaissance, Phaidon, 1972

Janson, H. W. *A Basic History of Art*, Prentice-Hall/Abrams, 1971

Levey, M. *Early Renaissance*, Penguin Books, 1967

Levey, M. *High Renaissance*, Penguin Books, 1975

Murray, P. *The Architecture of the Renaissance*, Thames & Hudson, 1969

Panofsky, E. *Renaissance and Renascences in Western Art*, Harper Torchbook, 1969

Plumb, J. H. *The Penguin Book of the Renaissance*, Penguin Books, 1964

Wolflin, H. *Classic Art*, Phaidon, 1952

ORIGINAL SOURCES

Alberti, L. A. *Della Pittura*, ed. Malle, Florence, 1950; (English edn.) *On Painting*, Yale University Press, 1967

Castiglione, B. *Il Libro del Cortigiano*, Mursia, Milan 1972, (English edn.) *The Book of the Courtier*, Dent, 1975

Vasari, G. *Le Vite dei piu eccellenti Scultori, Pittori e Architetti*, ed. G. Milanesi, Florence, 1878; (English edn.) *The Lives of the Artists*, Dent, 1970

Vespasiano da Bisticci, *Vite di Uomini Illustri*, ed. P. d'Ancona and E. Aeschlimann, Milan, 1951; (English edn.) *The Vespasiano Memoirs*, London, 1962

Glossary

ACANTHUS a plant with finely divided prickly leaves.

ALTARPIECE picture or carved/decorated screen behind and above the altar.

ARCADE range of arches, carrying a roof, supported by columns.

BAPTISTERY separate building where baptism was performed; a feature of Italian architectural activity until the end of the Middle Ages.

BAROQUE style in architecture, decoration and art generally which arose in the seventeenth century.

BASILICA term used for civic hall in a classical Roman city and for an early form of Christian church.

BYZANTINE style of art produced under the influence of the Eastern Roman or Byzantine Empire (330–1453); best known for its highly stylised religious paintings, mosaics and frescoes with a brilliant use of colour.

CHAPTER HOUSE place where abbot, prior and other members of a monastery, priory or cathedral chapter met to discuss their affairs.

CHROMATIC coloured.

CLASSICAL refers to the art of the Greeks and Romans and the later styles inspired by it.

COLONNADE series of columns placed at regular intervals.

COMMUNE type of political organisation of cities of Renaissance Italy.

CORINTHIAN the most ornate of the four classical orders of architecture; the columns have an inverted bell-shaped capital decorated with acanthus leaves.

CORNICE the horizontal moulding projecting along the top of the wall or arch, or at the juncture of walls and ceiling of a room.

CORNUCOPIA the horn of plenty, usually represented as a goat's horn overflowing with fruit, flowers etc.

DIPTYCH two pictures, hinged together like the pages of a book and free-standing when opened out. Frequently of religious subjects and for devotional use.

DONOR person who gave a work of art to a church; he would be included in the picture, initially as an insignificant figure, but by the Renaissance period as a significant part of the work.

DORIC most widely used of the four classical orders of architecture; the columns have no base and a plain capital.

ENGRAVING method of printing, by cutting lines of different width, depth and texture into metal or wood; printing ink is then rubbed in and the plate or block passed through a press.

ENTABLATURE in classical architecture, the horizontal sections supported by columns: architrave, frieze, cornice.

FAÇADE the main face of a building, usually that on the street.

FORESHORTENING perspective when applied to a single object or figure; the size of the object decreases as it recedes from the spectator so that the nearest part seems exaggeratedly large and the rest strongly contracted.

FORM the structure of a work of art, the proportioning and arrangement of the parts to make a harmonious whole.

FRESCO (Italian 'fresh'), a method of wall painting perfected in Renaissance Italy whereby the painter applies his colour to specially prepared wet plaster. The colour blends with the plaster, creating a very tough surface, the painting becoming part of the wall itself.

FRIEZE the decorated middle section between the architrave and the cornice of a building; also a band of carving around the top of a building or room.

GOTHIC term used to describe the architectural style, particularly of northern Europe from the twelfth to the sixteenth century, characterised by soaring heights, flying buttresses, spires, elaborate vaults, traceries and stained glass.

There was a Gothic revival in the nineteenth century.

HUMANISM intellectual movement of the Renaissance period, away from medieval theological courses of study and towards study of Greek and Roman classics, towards emphasis on human activities and capabilities rather than on the divine.

LOGGIA roofed area, open on at least one side.

MANNERISM style in Italian art *c.* 1520–90 characterised by distorted, elongated, serpentine figures, unclear compositions, exaggeration, frenzy, harsh colours and a general impression of strain and discord. It contradicted classical rules of art.

NAVE main body of church, often flanked by aisles.

PALAZZO (Italian 'palace') or imposing town house.

PALETTE board on which the artist mixes his colours; the range of colours used by a particular artist.

PATRON someone who supported an artist or commissioned works of art; usually a royal or wealthy personage, a church dignitary, or state or church body.

PERSPECTIVE, AERIAL use of changes of colour and tone to achieve effect of distance; based on fact that colour changes as object recedes from spectator.

PERSPECTIVE, ONE-POINT system for representing three-dimensional, i.e. solid, reality on a two-dimensional, i.e. flat, plane; based on the observation that objects in the distance appear smaller than those close to the spectator.

PIAZZA open space in a city or town.

PIETÀ (Italian 'pity') a representation of the dead Christ with his mother.

PILASTER a flattened column, attached to or built into a wall.

PLANE in a painting, simulated surfaces parallel to the surface of the canvas and receding in depth to create spaces in which to place people or things.

PORTICO a roofed space with columns on at least one side; often the entrance to a building.

RELIEF sculpture carved on a surface so that the figures project but are not free-standing.

RENAISSANCE term traditionally used to describe the period 1400–1530 when a 'rebirth' or 'revival' of intellectual and artistic activity based on classical learning and aesthetic models is said to have taken place.

ROUNDELS small circular panel, niche or window.

SACRISTY a small room in church where sacred books, vestments, vessels are kept.

SARCOPHAGUS tomb, often carved, of stone or marble.

SILVERPOINT the process or result of drawing with a silver-tipped pencil.

STIACCIATO relief work where the projection of the carving is the shallowest possible.

STOA covered area, with columns, as in classical Greek towns.

STUCCO lime-plaster used as a base for decorative work on buildings.

TONDO circular relief carving or painting.

TRACERY decorative openwork, usually stone.

TRIBUNE raised area in Roman basilica where officials sat; possibly derivation of position of Christian bishop's throne in church.

TRIPTYCH three painted panels, hinged together.

VAULT arched roof made of brick or stone.

VOLUME in art, when the feeling of three-dimensional space is dominant.

Index